Transmediation
in the Classroom

Studies in the
Postmodern Theory of Education

Joe L. Kincheloe and Shirley R. Steinberg
General Editors

Vol. 176

PETER LANG
New York • Washington, D.C./Baltimore • Bern
Frankfurt am Main • Berlin • Brussels • Vienna • Oxford

Transmediation in the Classroom

A Semiotics-Based Media Literacy Framework

EDITED BY

Ladislaus M. Semali

PETER LANG
New York • Washington, D.C./Baltimore • Bern
Frankfurt am Main • Berlin • Brussels • Vienna • Oxford

Library of Congress Cataloging-in-Publication Data

Transmediation in the classroom:
a semiotics-based media literacy framework / Ladislaus M. Semali, editor.
p. cm. — (Counterpoints; vol. 176)
Includes bibliographical references and index.
1. Communication in education. 2. Semiotics. 3. Media literacy.
4. Mass media in education. I. Semali, Ladislaus.
II. Counterpoints (New York, N. Y.); vol. 176.
LB1033.5 .T73 371.33—dc21 2001046275
ISBN 0-8204-5199-1
ISSN 1058-1634

Die Deutsche Bibliothek-CIP-Einheitsaufnahme

Transmediation in the classroom:
a semiotics-based media literacy framework / ed. by: Ladislaus M. Semali.
–New York; Washington, D.C./Baltimore; Bern;
Frankfurt am Main; Berlin; Brussels; Vienna; Oxford: Lang.
(Counterpoints; Vol. 176)
ISBN 0-8204-5199-1

Cover design by Dutton & Sherman Design

The paper in this book meets the guidelines for permanence and durability
of the Committee on Production Guidelines for Book Longevity
of the Council of Library Resources.

© 2002 Peter Lang Publishing, Inc., New York

Printed in the United States of America

To Aika
And Children Everywhere,
Not afraid to transmediate

Table of Contents

Preface

Ladislaus M. Semali

Transmediation in the Classroom is a new addition to the growing litera-
ture in recent years in the field of critical media literacy. The authors chal-
lenge and critique the traditional teaching methods still prevalent in some
U.S. public schools. They observe that in English and language arts class-
rooms, the practice of teaching that language and "reading" are the only
sources of knowledge is misplaced. Historically, language arts programs
have been largely verbocentric, focusing more on "language" than on the
"arts" (Fueyo 1991). Within this tradition, language is viewed as the dom-
inant way of knowing, particularly in the context of schooling, where oral
and written language are thought to be the necessary precursors to the
acquisition of knowledge. However, the image of classrooms as places
where teachers talk and students listen, memorize, practice, drill, or dis-
play knowledge is fading rapidly.

Although educational reforms loom large, they are not happening
without pull and push from neo-conservatives whose ideological posi-
tions can be described by two phrases: back-to-basics education and
state-mandated teacher-proof curriculum standards (Darder 1999). Back-
to-basics education and an emphasis on standards characterize the trans-
mission model of teaching, which is steeped in pragmatic, skills-based
approaches that rely on rote learning and lecturing. At its core, however,
the neo-conservative movement promotes an instrumental language that
defines education as scientific cognitive skills that are technically objec-
tive and value free. Within this model, classroom knowledge is viewed
"as independent of human beings and as independent of time and place;
it becomes universalized, ahistorical knowledge" that deceptively cam-
ouflages the curriculum's hidden motivations (Giroux 1983). As long as

ture to represent their world, what do such enterprises tell us? What implications can we infer from such lessons for school curriculum, pedagogy, and assessment? Can signs and codes in popular media carry "hidden" meanings and ideologies of race, gender, class, disability, and sexual orientation? Are students (or other viewers) vulnerable, innocent, enslaved, or in need of protection from popular media? Or are they empowered viewers who can (re)interpret, question, and disrupt media texts? Both veteran and pre-service teachers are asking these questions too.

The authors of *Transmediation in the Classroom* chose to focus on semiotics because semiotics has the basic terminology or language that allows them to talk about all signs, whether they consist of language or symbols and whether they are drawn from the auditory, the visual, or the tactile. Semiotics is commonly understood as a systematic and scientific study of all factors that enter into the production and interpretation of signs (messages). Overall, these chapters expand on the themes of our preceding volumes dealing with critical media literacy in the classroom: *Intermediality: The Teachers' Handbook of Critical Media Literacy* and *Literacy in Multimedia America: Integrating Media Education across the Curriculum*.

In *Transmediation in the Classroom*, we conceptualize critical media literacy as a transmedial process. In this process the interpretation and correlation of signs constantly interplay. Grounded in a constructivist approach, the teaching frameworks that the authors outline here aim to explore how students experience transmediation in language arts and literacy education classes. Unfortunately, to date, few instructional programs designed to teach inquiry-based reading, critical thinking, or media analysis draw on contemporary research in semiotics as a potential resource for instruction. We believe that a constructivist approach to the exploration of semiotic representation can promote a new way of looking at curriculum and instruction. In this endeavor, we hope to facilitate and pave the way for practitioners and researchers alike to follow as they teach reading, writing, listening, speaking, thinking, and viewing in the twenty-first century.

The frameworks outlined in the following chapters derive from contemporary research on signification, representation, and the study of signs. By including these frameworks in this volume, the authors push critical media literacy to a new height. They show how students begin to interpret complicated signs in wider realms of social ideology—the gen-

eral beliefs, conceptual frameworks, and value systems of society—while using the theory of semiotics to uncover the complexity of the representation of race, class, gender, disability, and sexual orientation. The advantage of talking about the function of signs in classrooms as a correlation of content and interpretation is that it can help students appreciate the complexities of using two or more different sign systems to make meaning. This practice is becoming increasingly necessary in multimedia classrooms.

The first four chapters of this volume set the stage of the work. Chapter 1 reviews the theory of semiotics and puts in some perspective what we already know about semiotics and media analysis. This chapter provides the theoretical framework from which the rest of the chapters and the frameworks derive. In Chapter 2 Judith Fueyo describes her own experience of transmediation and the dilemmas an educator faces as both a classroom teacher and an artist in trying to come to terms with multiple signs as a form of expression as well as a form of self. In Chapter 3, Mary Napoli presents a classroom example that outlines ways to teach critical literacy in lower grades and at the same time allow these young students to represent their world through multiple sign/symbol systems. In Chapter 4, Pei-Yu Chang shows the interconnection between play and art in the context of her work with children in Taiwan. Chang's chapter also illustrates the role of the teacher as playmate, caretaker, and mentor of children, and thus shows how teachers mediate meaning for young learners through an intimate socialization process.

In Chapters 5, 6, 7, 8, 9, and 10 Deb Marciano, Richard De Gourville, William Garcia-Cardona, René Antrop-Gonzalez, Arda Arikan, and Sarah Green take up the issue of representation and illustrate the many signs and symbols used in picture books, popular music, cinema, photographs, gendered television programs, and ESL/EFL instruction.

In the past, scholars have not undertaken an analysis of media representation of race, class, and gender in a semiotic framework. Previous studies have used sociological and anthropological methods of analysis. This book is aimed at teachers, students, researchers, and other educators who are considering the ways in which issues of ideology are relevant to the understanding of media representations of race, class, gender, and so forth. The key factor around which the book develops its argument is the importance of sustaining a theory of ideology and curriculum that can be productively related to the analysis of issues of race, identity, or media representations.

In Chapter 11, Jamie Myers outlines the assumptions of semiotic representation of critical literacy and the important lessons to be drawn from this work. He rightly argues that a transmedial experience is not necessarily a critical literacy project. Teachers have to embrace a transformative perspective within a constructivist context in which inquiry, reflection, and action become the driving engine of the learning experience.

Since the studies in this collection are provisional reports from the field, I would like to encourage the readers of this book to apply the frameworks suggested here in their teaching situations and report on their successes or limitations. I urge the reader to try out the models and adopt the concept of diagnostic critique as envisaged in critical pedagogy when engaging students in the conversation of media representations of race, class, and gender. It is through such diagnostic critique that I believe educators can foster a critical mindset in our students. This means cultivating the ability to ask difficult questions and the self-confidence to reject easy answers—the two fundamental goals of a critical inquiry.

References

Darder, A. 1999. *Culture and power in the classroom. A critical foundation for bicultural education.* Westport, CT: Bergin & Garvey.

Eisner, E. W. 1990. The role of art and play in children's cognitive development. In *Children's play and learning*, edited by E. Klugman and S. Smilansky. New York: Teachers College.

Fueyo, Judith. 1991. Reading literate sensibilities: Resisting a verbocentric writing classroom. *Language Arts* 68: 641–648.

Giroux, H. 1983. *Theory and resistance in education: A pedagogy for the opposition.* South Hadley, MA: Bergin & Garvey.

Short, K., G. Kauffman, and L. Kahn. 2000. I just need to draw: Responding to literature across multiple sign systems. *The Reading Teacher* 54, no. 2: 160–171.

Siegel, M. 1995. More than words: The generative power of transmediation in learning. *Canadian Journal of Education* 20: 455–474.

Chapter One

Transmediation: Why Study the Semiotics of Representation?

Ladislaus M. Semali

> Thought and language, which reflect reality in a way different from that of perception, are the keys to the nature of human consciousness. Words play a central part in the historical growth of consciousness as a whole. A word is a microcosm of human consciousness. (Vygotsky 1962, 153)

The process of taking understandings from one sign system and moving them into another in order to make meaning is the overarching theme of this book. Suhor (1984) characterized this process of translating or representing content as *transmediation*—mediating or "representing" meaning across sign systems. He perceived transmediation as a syntactic concept since it deals with the structure of sign systems and the relationship between different sign systems.

Borrowing from semiotics, the authors of this volume explore as educators and researchers the relationship of visual and verbal abilities found in students. Our central concerns are two: First, what is the relationship between what the students know and the signs they encounter in their classrooms about race, class, gender, disability, and sexual orientation? What meaning do they make of these semiotic systems? Second, how are the signs representing race, class, and gender combined into codes? As educators, the authors are primarily interested to know how learners create and manipulate signs, specifically visuals found in the multimedia classrooms of the twenty-first century. In this enterprise, we believe semiotics is appropriate in the investigation of these concerns.

At its most basic, semiotics is the study of sign systems: what signs mean, how they relate to one another, and how they are manipulated (Morris 1971). We chose to focus on semiotics because, as Morris shows, semiotics has the basic terminology or language that allows us to talk of

all signs, whether they use language or symbols and whether they are drawn from auditory, visual, tactile, or proprioceptive stimuli. Through semiotics we can analyze how linguistic and nonlinguistic cultural "signs" form widely understood systems of meanings—as when giving a rose is a sign of love or smoke is a sign of a fire or getting an "F" on a college paper is a sign of failure to master the requirements of the specific assignments. A great deal of Morris's work reflects the framework of his predecessor Charles Pierce. Pierce's (1961) work focused on the triad of the ways a sign can be related via an "interpretant," to its object and what this threefold relationship tells us about the ultimate conditions of semiosis (i.e., the process of the production and interpretation of signs). The so called "standing for" relationship which always involves a mind and processes of "abstraction" will be described in detail in Chapter 11. However, suffice it to say that the triad semantic relationship between indexes, icons, and symbols as suggested by Pierce is the basis of all human communication. For Pierce (1961), iconic signs carry some quality of the thing they stand for, as when a portrait stands for a person. Under icons Pierce included not just realistic images but also such expressions as algebraic equations, graphs, diagrams, maps, and even metaphors. Indexical signs point to the existence of what they stand for, as when smoke stands for fire. Indexes are embodied and actuated in gestures, demonstratives, personal pronouns, field markers, and so forth, to signify the existential or physical connection with their objects. Symbolic signs arbitrarily stand for something through a process of consensus, as when a word stands for a concept. Symbols signify objects but to a large extent their signification is governed by conventions and rules even though it is assumed that there is no immediate or direct bond between symbols and objects. Ferdinand de Saussure and his followers explored this area of study extensively.

The general theory of semiotics and the classification of signs provide us with a deeper understanding and appreciation of the complexity of human communication with signs, symbols, and images. From this semiotic perspective, the authors of *Transmediation in the Classroom* puzzle over two issues: First, since signs are all around us, why then does the school curriculum not value and encourage the development of abilities other than verbal, given that only a small proportion of communication is verbal? Second, why does the process in which thought and language represent reality continue to be taken for granted in classrooms in many pub-

lic schools and why do many semioticians think that this process is critical to the understanding of how humans produce knowledge?

What Is Semiotic Representation?

Semiotic representation is a way of talking, thinking, and interpreting the sign systems that stand for or "represent" meaning embedded in texts about race, class, gender, disability, sexual orientation, and other identities. This semiotics-based approach examines sign systems as vehicles of meaning in a culture and looks at how such sign systems are taught to children and adolescents and how they capture societal values about human relationships, myths, belief systems, and established norms. To realize the complexity of how humans produce knowledge, one needs only to ask a series of simple questions: How did we come to know what we know? What is fact and what is fiction about what we know? In a virtual world of hypermedia, how much of what we know is reality and how much is fantasy? Which signs stand for myth, stereotype, or bias? As the mass media, from which we obtain information and much of what we know about the world around us, become the main source of our daily input, the lines between truth, fiction, and history get blended (Semali and Pailliotet 1999). How then do we begin to unravel this complexity?

The authors of *Transmediation in the Classroom* ask the following questions: How do students make sense of what they learn? What contradictions exist in the knowledge they acquire, invent, or interpret from the classroom texts? What are the different sign systems representing race they encounter in their classrooms? How do students come to learn, interpret, and negotiate the meaning of race from the variety of sign systems they encounter in their school life? Why is the study of race and racial representation not taken up systematically in the curriculum of U.S. public schools? How is what students know about race mediated or represented in signs? Which signs are significant to their knowledge about race? To date, few studies have ventured in this arena to explore these questions.

The authors of *Transmediation in the Classroom* realize that the invention or production of knowledge outside the walls of the classroom is made possible today through technologies—the Internet, hypermedia, software, and so forth—in our classrooms and beyond. To put it simply, the authority of teachers and the certainty of what was learned from them in the classroom and regarded as stable and absolute has begun to slip and slide into uncertainty. With the introduction of computers, the Internet,

and a plethora of ways to access academic resources that come with these technologies, knowledge is being democratized and the tide is drifting away from the transmission approaches. Now, more that ever before, students are encouraged to bring what they know and have learned in their communities into the classroom. In addition, many students have access to the Internet, which is another source of knowledge. In this information age, some students are thrilled to see themselves as knowledge-makers who find and frame problems worth pursuing, negotiate interpretations, forge new connections, and represent meanings in transmedial ways. Teachers are therefore challenged to consider other methods to teach and lead students in the understanding of sign systems ushered into the classroom by multimedia technologies.

Theoretical Grounding of Semiotic Representation

Transmediation in the Classroom owes much of its theoretical underpinning to the work of Eco, Hawkes, Bunn, and Guiraud. These works offer penetrating and provocative introductions to the vast range of problems and issues of semiotics. For example, Umberto Eco's *A Theory of Semiotics* (1976) touches upon all the main topics of semiotics, both methodological and substantive. Although Eco's volume is written at a fairly advanced level, it provides both historical and philosophical sophistication. Terence Hawkes's *Structuralism and Semiotics* (1977) surveys the connection of semiotics to structuralism and its bearing upon many problems and issues in linguistics, anthropology, and the vast domain encompassed by literature and literary theory. James Bunn's *The Dimensionality of Signs, Tools, and Models* (1981) offers yet another approach to the classification of signs and their respective functions that is based on their belonging to one of the various Euclidean dimensions. It focuses upon the contribution of signs to the processes of discovery and utilizes a wide range of stimulating and heuristically important examples. Pierre Guiraud's *Semiology* (translated by George Gross, 1975) offers many stimulating analyses and clear models of semiotic procedures and categories. These semioticians have been studying in a systematic and comprehensive way the many questions the contributors raise in this book. For example, in a virtual world of computers, what is a sign? Where do signs come from? How many types and kinds of signs are there? What is the basis for their classification? What are their respective powers? What meanings do they give when juxtaposed with one another? What are the various uses to which they can be put? As we try to relate thought

and language as signs and symbols, we cannot overlook the work of semi-oticians such as Eco, Hawkes, and Guiraud.

Semiotics studies the sign-dependent and sign-constituted artificial medium and process by which human beings "weave symbolic net, the tangled web of human experience" (Cassirer 1975). The most basic prem-ise of semiotics, one that comes independently from a number of sources, is that signs mediate all that human beings can know. This is inherent in the work of three semioticians: Charles Sanders Pierce, Umberto Eco, and Jakob Von Uexküll. As a basic unit, the sign makes the study of the full range of communication behaviors possible. According to Peirce, a sign is anything that can stand for something else; for Eco, a sign is any-thing that can be used to tell a lie; and for Von Uexküll (1940), a sign is any meaning-carrier.

When we talk about teachers and students engaging in a transmedial experience, we are talking about their abilities to engage in multiple ways of mediating knowing between sign systems. Such critical engagement involves more than reading and writing in a passive way. It involves an active textual analysis from a multiplicity of perspectives and critical methods. When students, for example, are able to draw meaning from symbols or signs juxtaposed side by side, they are said to construct mean-ing intertextually. Intertextuality refers to the process of making connec-tions with past texts in order to construct meaning of new texts. Readers understand the new by searching past experiences with texts and with life to find connections that will bring meaning to the current text. This process is often automatic and even unconscious. The greater the range of experiences and texts considered, the deeper the level of meaning (Pailliotet 1999). Typically, intertextuality is defined as the connection students make between pieces of written literature. In a multimedia world of the Internet and the information superhighway, the definition of text is no longer limited to just the printed text. A text can be a novel, a piece of art, a play, a dance, a song, or a mathematical problem expressed in an algebraic equation or graph.

Students come to school with extensive knowledge about the Internet and about visuals from a variety of sources, including television, films, cartoons, picture books, and graphics of different kinds. Because they are visually literate, these twenty-first-century students draw from a wide repertoire when they construct new knowledge. The most common inter-textual connections that students make are to movies and the mass media, especially pop music. These texts fill their lives and are a natural point of

connection. They constantly refer to Nintendo or to *Beavis and Butthead*. While teachers do not value such intertextual connections to the movies and to Saturday morning television cartoons, these are the most easily accessible texts for children and adolescents and they are a significant point of reference for their views of texts and life.

Learners who transmediate are exposed to the theories and curriculum practice that will value multiple literacies. These multiple literacies aim toward a practice that is multiperspectival, multidimensional, and multicultural (Kellner 1995). A *multiperspectival* practice acknowledges the multiple perspectives and subject positions individuals bring with them when they interact with cultural texts. A *multidimensional* practice examines the multiplicity of levels embedded in a cultural text from the literal level to its context. A *multicultural* practice sees the importance of analyzing the dimensions of class, race, ethnicity, gender, and sexual preference within the texts of media culture and seeing as well as their impact on how audiences read and interpret media culture. Collectively, these practices go beyond the superficial image or symbol to attack the representations of sexism, racism, or bias against specific social groups and criticize texts that promote any kind of domination or oppression.

Ideally, semiotic representation, when conceptualized within the multiple literacies context, provides a full and adequate reading of the complex multimedia environments where multiple sign systems play a crucial role in the construction of meaning(s) and identity. Students who are versed in transmedial literacy of this kind will critically read and write with and across varied symbol systems (Barthes 1974; Fiske 1989). By "reading" we don't just mean passively receiving information or decoding print but rather interacting with text to make mental images that help us to understand the world around us. By "writing" we mean generating texts through a myriad of media or sign forms. According to semiotic theory, these sign systems that we have created to express meaning and to mediate our world offer different perspectives of the world around us. Berghoff (1993) argues that "music can express feelings we cannot put into words; language is a better medium for humor than math; yet math can represent concepts that are not easily represented in art, and so on" (218). What might this mean to a teacher and to young learners?

In a transmedial experience, we are interested in how students take what they understand through language as they read and talk about literature and transform these understandings by expressing their ideas in play, drama, music, or math and taking action regarding their new knowl-

edge. When students take their understandings from reading a book and consider them in another sign system (or media form) this transmediation experience provides them with an alternative perspective and supports them in more complex thinking. Even though the most obvious sign system used in education is verbal language, in which words stand for ideas, Eco (1976) cautions us that sign systems such as verbal language are not unitary nor do they operate in a closed circuit. He suggests that signs often create other signs ad infinitum. The interpretation of one sign creates another. This being the case, then, all signs are interconnected.

According to Eco, there are two implications of semiotics for education. First, the segmentation of knowledge into fields or subject matter is arbitrary. Anything we can know is inextricably linked with everything else we can know. There are multiple paths to any one piece of knowledge and no one path can necessarily be considered a superior route. The second implication is that as we investigate and interpret signs we are in effect creating other signs that may potentially become the object of investigation and interpretation—a rather elegant argument against the notion that we can ever know everything there is to know about the world we live in. It also suggests that we, as sign-creators, are the very source of that which we study. Von Uexküll's (1940) theory of meaning states this plainly. The physical world is not a disjointed mass where independent entities intermingle; but rather it is made up of interdependent entities locked in a continuous dance of mutual creation.

Why Study Semiotic Representation?

As implied in the quotation at the outset of this chapter, the human ability to transmediate is central to human consciousness and human understanding. A human being is by nature a sign-manipulator. However, only a small percentage of human communication is verbal; a vast amount of communication takes place on the nonverbal level. So why is it important to examine the sign systems of a visually literate culture? What could we learn from such investigation? How might teachers create pedagogical frameworks to demonstrate and model for students how to value critical reading, critical viewing, and critical authoring of visual culture? As explained in the previous section, semiotics provides us with insights to answer this question adequately. It provides us with the concepts to understand the language of transmediation. It is for this reason that the authors of this volume avoid the limitations of the transmission teaching approaches. They support a method of teaching that is less fragmented

into fields or subject matter, one that promotes thematic unit planning, multiple ways of knowing, whole language, critical literacy; and one that also aims to focus on student-centered learning that integrates technology across the curriculum. These educators encourage students to come to school technology-ready and cyber-savvy in a virtual world of computers. Even if teachers choose not to participate in the technological advances of the future, their students come to school demanding to use in the language arts classrooms, and in classrooms of other disciplines, what they already know from the Internet. The so-called transmission model of education has in the end become increasingly limited, giving way to instructional transmediation.

In this technological boom era, one of the sign systems we use to communicate nonverbally is the visual sign system. This sounds like an understatement. Fiske and Hartley (1978) list different kinds of signs and codes of television in their book *Reading Television*. The fact is that individuals born in the media age are savvy and very good at transmediating. In their lives outside school, students naturally move between art, music, movement, mathematics, play, and language as ways to think about the world. They talk and write, but they also sketch, sing, play, solve problems, and dance their way to new insights. It is only in the schools that students are restricted to using one sign system at a time to think (Short, Kauffman, and Kahn 2000, 160). A multiple use of signs becomes a transmedial experience par excellence.

The ability to transmediate is perhaps best manifested when one is immersed in a multimedia environment. For instance, magazines and newspapers consist of more than words. They use a variety of elements, which we call media (editorial) language, to communicate its stories to audiences effectively. Clearly, the elements of the editorial language are what linguists have conveniently called *signs*. The variety of sign and symbol systems found in a magazine coalesce to create its popularity. In any magazine, you will find photographs, illustrations, graphic letters, and advertisements printed in a variety of modes and forms on almost every page. Without thinking, readers read or skim through the pages to draw a comprehensive understanding of what the messages are all about. Afterward, they, in turn, are able to retell the story of the narrative or relate the visuals verbally to a friend. Perhaps by using what I conveniently call a transmedial experience, readers are able to gather precise meaning(s) about a particular story without concern about the symbols used, the images inscribed, or the graphics sketched.

But how do audiences make meaning of what is communicated by such editorial language? What is real? Where in the world does meaning reside? Where and how do people assert agency in everyday life? It seems to me that reality is different for different people and that people create meaning in social interaction. This sociological theory of symbolic inter-actionism suggests that both reality and the social order are created by people as a process of joint action (Blumer 1969).

According to symbolic interactionism, people live in a world of objects that become meaningful according to how others relate to them—according to how others act in ways that reveal the meanings they attach to those objects. The early twentieth-century sociologist George Herbert Mead (1938) put it this way: "Living things are involved in relationships of mutual determination with the environment and are not merely respon-sive to the pre-existing world around them" (14). In other words, living things negotiate the world's meaning together. Working from these assumptions, when I enter schools and classrooms as a researcher, I expect to see students *negotiating* meaning and in that process *construct-ing* their share of social and cultural reality. I expect to see students in *interaction* creating a context for real events, and I expect to see the lan-guage events they create in turn creating the context. Thus, I see reality as reflexive. I believe that while a social order exists, "its existence always appears within interaction" (Sebeok 1976, 184). That is to say that most of the time, people feel and experience the privileges and the restric-tions of their place within the larger social order in their interactions with other people. It is not, therefore, any abstract knowledge of how society is structured that makes real the existence of societal structure. What seems to make these structures real are perhaps all the concrete details involved in dealing with other people.

We are puzzled: Then what really goes on in a transmedial experi-ence? How do we come to understand what we see? What does the edi-torial language and its rich symbolism, images, and signs do to our psyche? How do the signs influence what we see or want to see in the edi-torials? In the pictures? In the graphics? When do signs stand for a myth? A stereotype? A bias? In short, how do we come to know what we know and feel good about knowing it? How do signs represent reality? How are we able to read and use multiple sign systems? Why don't teachers in some schools value such transmedial experiences? These rhetorical ques-tions sum up the overarching question posed in the title of this chapter: Why study semiotic representation? Our task in this work is to seek

responses to these questions. We focus on multimodal learning and in the process we try to unpack the ways in which language and other sign systems operate both in specific instances of learning and throughout the curriculum more generally.

To conclude this discussion, we might sum up with the following set of propositions that form the basis of the constructivist position:

1. Language is a continuous generative process implemented in the social-verbal interaction of speakers.

2. The laws of generative process in language are not at all the laws of individual psychology, but neither can they be divorced from the activity of speakers. The laws of language generation are sociological laws.

3. Linguistic creativity does not coincide with artistic creativity nor with any other type of specialized ideological creativity. But at the same time, linguistic creativity cannot be understood apart from the ideological meanings and values that fill it (see Volosinov 1985, 65).

In a nutshell, we appreciate the complexity of how humans produce knowledge in the web of sign systems, including language. Because of this complexity, this chapter provides, by implication, the rationale why teachers might consider adopting frameworks that use multiple sign systems as part of the reading and writing curriculum. By multiple sign systems, we mean multiple representational ways of seeing, multiple ways of doing, and multiple ways of knowing the world around us (Short and Harste 1996). When students and teachers combine words, pictures, and mathematical symbols to express their ideas, they are said to transmediate. A truly literate person is one who can mediate his or her world through multiple sign systems—not just language. How can we set up classroom environments that support students in thinking like artists? Like musicians? Like mathematicians? Like dramatists?

Instructional Transmediation

Transmediation in the Classroom provides a framework for the theory and practice of using multiple sign systems to generate multiple perspectives in what students learn in today's multimedia classrooms. As a ped-

agogical method of inquiry, instructional transmediation—the process of translating meaning from one or several sign systems to another—is a semiotics-based approach that explores the analysis of sign systems as vehicles of meaning in a culture in curriculum instruction. Charles Suhor (1984) first introduced the term transmediation as part of his development of a semiotics-based curriculum. Suhor, a language educator interested in integrating media and the arts across curriculum, defined transmediation as the "translation of content from one sign system into another" (250)—for example, the translations involved a transfer of meaning from a storybook to a picture book, from folklore to a storybook to a play, or from a story to an illustration or drawing.

In Suhor's terms, a semiotics-based approach looks at meanings and messages in all forms and all contexts. For example, when students analyze the texts, symbolic representations, picture books, images, and value systems of multimedia texts that are found in a media literacy classroom, they begin to transfer what they know from one sign system to another, say to a system of printed words, sounds, gestures, and expressions that represent the meaning-systems of our culture. When students examine these texts in the context of their multimedia world, they realize that material objects and museum artifacts as well as sounds, gestures, pictures, and expression function as signs that communicate meaning.

The Swiss linguist Ferdinand de Saussure first operationalized this semiotic analysis of texts, which is based on semiology, the science of signs. He laid the foundation for analyzing signs into two identifiable parts: the *form* or the actual word or image or picture and the *idea* or concept in your head with which the form was associated. Saussure called the first element the *signifier* and the second element—the corresponding concept it triggered off in your head—the *signified*. Thus, every time students hear or read or see the signifier (the word or image or object) it correlates with the signified (or a concept of it). To make sense of such sign systems, one could think of letters and flashcards in the first grade: We can remember that a tree was a word on the flashcard, then that a tree was shown as a picture, and finally that it was an artifact (object) in the forest or museum. Thus, the three sign systems become evident. Saussure concluded that both elements—the signifier and the signified—are required to produce meaning.

On the basis of this understanding, it becomes clear, Saussure suggested, that at the heart of transmediation are two related "systems of representation of meaning." The first enables us to give meaning to the world

by constructing a set of correspondences or a chain of equivalent comparisons between things—people, objects, events, abstract ideas; our conceptual maps. The second depends on constructing a set of correspondences between our conceptual map and a set of signs, arranged or organized into various languages that stand for or represent those concepts. The relation between "things," concepts, and signs lies at the heart of the production of meaning in language within a culture. The process that links these three elements together is what Hall (1997) defined as "representation" (19). For Hall, media representation is a way of giving things meaning by how we (re)represent them—the words we use about them, the images of them we produce, the emotions we associate with them, the ways we classify and conceptualize them, and the values we place on them (3). In other words, media representation refers to the way images and language actively construct a web of meanings according to sets of conventions shared by and familiar to makers and audiences.

When this definition of signs and its correspondences are translated into teaching terms, we begin to see that through the system of representation, we seek to know, to learn what is beyond the artifact. We wish to discover or articulate how the language of the artifact (that is, aural, visual, or written codes) becomes linked to the "mental representations" (images or concepts) about people, objects, or events (real or imagined). If we extend this definition to include "the various ways in which we organize, cluster, arrange, and classify concepts, thus establishing complex relationships between them, it becomes clear how our mental schemes produce images and meanings that we might construct from our encounters with people, objects or events" (Hall 1997, 19). It is through the process of transferring image to representation that qualities are affixed to certain ethnic groups (for example, all Asians are businesspeople) such that those qualities come to portray an inescapable norm or standard by which every group member becomes judged. In short, Hall infers that by this process representation is the production of the meaning of the concepts in our minds through language. It is this link between concepts and language that enables us to refer to either the "real" world of objects, people, or events, or to imaginary worlds of fictional objects, people, and events (17).

With Suhor's (1984) framework in mind, *Transmediation in the Classroom* is grounded in the overarching assumption that humans use multiple sign systems or codes to make sense of any human experience or the world around them.

This view of multiple sign systems (or multiple perspectives) coincides with what Saussure meant when he suggested that "all events in human experience are texts waiting to be read." For Saussure, according to Jonathan Culler (1976, 19), the production of meaning depends on language. However, when the term "language" is postulated this way, it requires a broader context to include "a system of signs, sounds, images, written words, paintings, photographs, and so forth, all of which function as signs when they serve to express or communicate ideas" (19). The narrowly conceptualized practice of teaching language and "reading" as the only source of knowledge (what Fueyo refers to as "verbocentric" teaching) falls short of capturing this broader context of multimedia and multiform means, a reality in which many students find themselves in the twenty-first century.

Hence, in a transmediation experience, students struggle to tease out multiple sources of information (signs or codes through which meaning is communicated) to achieve understanding in broad perspectives or deeper meaning. In the pursuit of such deep meaning, students encounter a multitude of symbols, codes, and sign systems that they must constantly interpret. Since the process of interpreting text is not straightforward, it becomes difficult to disentangle decisively. The underlying assumption of *interpretation* is that meaning has to be actively "read," "analyzed," or "explained." And when an explanation is not readily available because of inherent contradictions, the dominant ideology or myth is adopted as a way to explain the "way it is" or the "way things are." Because the practice of semiotics requires readers to constantly interpret all textual narratives, scholars must contend with the necessary and inevitable imprecision in the meaning of media texts (Hall 1997).

For example, the meaning we take as viewers, readers, or audiences is never exactly the meaning that was given by the speaker, by the writer, or by other viewers. All representations are constructions and need to be interpreted for "authentic" meaning. However, what is considered "authentic" by one individual may not necessarily be authentic for other readers or viewers. The authors of *Transmediation in the Classroom* realize that to get to the values, interests, and desires in media representations, one has to examine the use of language or signs and images that stand for, or represent, things. This involves a complex process because the meaning produced or constructed by representation is not definite; it does not represent universal truths or neutral facts. But it cannot be read in a straightforward manner either. Therefore, interpretations never pro-

duce a final moment of absolute "truth." Instead, interpretations are followed by other interpretations in an endless chain (Hall 1997, 42).

In an effort to understand how sign systems function in a classroom context and the interpretation that accompany them, the contributors of *Transmediation in the Classroom* explore a variety of classroom contexts where students engage in the interpretation of texts. They affirm that in the majority of sign systems found in media texts, human experience is mediated in *multiple* ways. As humans, we constantly use multiple sign systems to represent our ideas, particularly within the context of our culture or social environment. However, there is no one sign system that is an end in and of itself. For example, as humans gather information, they consciously or unconsciously consult multiple sources, some of which may be embedded within the same medium being consulted.

As aptly noted by Hall (1997), the fact of the matter is that we use a variety of elements to communicate meaning. For instance, we use sounds in spoken language, and we use words in written language. In music, we use notes on a scale; in body language, we use physical gesture; in the fashion industry, we use clothing, and so on. Also, these elements—sounds, words, notes, gestures, expressions, and clothes—are part of our natural and material world. Although these elements do not have any clear meaning in and of themselves, they form important media that transmit meaning for us because they operate as symbols that stand for the meaning we wish to communicate. These elements function as signs that *represent* our concepts, ideas, feelings, in such a way as to enable other people—friends, relatives—to *read*, decode, or interpret their meaning in roughly the same way we do. But to realize the meanings being sought, members of the same culture must share sets of concepts, images, and ideas that enable them to think and feel about the world and thus interpret the world in roughly similar ways. In other words, "they must share the same cultural codes" (Hall 1997, 4).

Until today, Suhor's approach to instructional transmediation was known not only because it elevated the linguistic system above all others but also because it connected language to all other sign systems. This may sound confusing. The term *language* may confound the reader here because it is being used outside its ordinary sense. As noted by Hall (1997), languages are "systems of representation." But when used in its broadest sense, language refers to all the different ways of producing and communicating meaning. Therefore, we must keep in mind therefore that when the authors of *Transmediation in the Classroom* write about media

languages, they imply that the mass media have their own language—their own sign systems, their own ways of organizing and symbolizing meaning. But so do visual images—whether produced by hand or by mechanical, electronic, digital, or some other means—when they are used to express meaning. And so are other things that aren't linguistic in any ordinary sense: the language of facial expression or of gestures, for example, or the language of fashion. When the term "language" is used in this special sense, then, it means more than simply the written and spoken means of communication. When we talk about media texts, we refer to all signs and symbols that mediate meaning to us. In a semiotics-based media literacy framework, students analyze media languages—they examine the signs and symbols in the media text, whether they are sounds, written words, electronically produced images, musical notes, or even objects—which stand for or represent to the reader, viewer, or audiences the concepts, ideas, and emotions of the author or producer. In producing texts, they use similar signs and symbols.

Extending Transmedial Experiences

Transmediation in the Classroom brings to classroom teachers and students frameworks for analyzing media texts. In the past, textual analysis in traditional classrooms was confined to the literary scrutiny of printed words. Students analyzed stories, plays, poems, essays, and novels. Today, even though this literary analysis has expanded to include visual images and electronic messages, analysis has remained limited to response-centered transactional approaches. Teachers using these approaches are often content to seek to see in literature what has previously been invisible and to hear what has previously been inaudible. Unfortunately, by adhering to a traditional reader/viewer response model, teachers in English classrooms maintain that their approach fosters critical thinking and critical literacy skills, unsuspectingly ignoring a semiotics-based analysis of media texts.

A semiotics-based instructional approach involving multilevel/multimedia textual analysis takes into account the transmedial translation of meaning from one sign system (such as spoken or written language) into another (such as music or visual/pictorial representation). It also accounts for meaning generated when two or more signs are juxtaposed side by side. The contributors of *Transmediation in the Classroom* believe that instructional transmediation promotes the kind of critical thinking that goes beyond memorization, drill, and display of received meanings to

include the invention of new connections and meanings. Furthermore, scholars such as Marjorie Siegel, a language professor at Columbia University (1995), see in the new ways of instructional transmediation an opportunity for teachers and students to go beyond the typical uses of language and words that were dominant in traditional classrooms. Through instructional transmediation, teachers and students must struggle to find analytical strategies that cut across symbols, codes, and sign systems that confound content. The assumption underlying this process is that in the end, students will be able to interpret more accurately textual references and social contexts found in school structures, literature, and modern mass media, all of which tend to perpetuate inequalities and bias on the basis of social class, race, gender, disability, sexual orientation, and so on.

Because of its generative power, Siegel is convinced that transmediation can help students forge new ways to negotiate meaning and produce knowledge. It is this generative power that the contributors of this volume see in the potential of critical media literacy. They wish to explore the semiotic basis of this claim in critical media literacy and its implication for alternative curriculum approach. In exploring the implications of instructional transmediation, the authors of *Transmediation in the Classroom* are encouraged to know that other scholars working in a variety of disciplines have argued rightly that students do not come to school as clean slates. In a variety of publications, these scholars insist that teaching and learning cannot be reduced to the transmission of information from teacher to learner through language. This view is clearly consistent with what Paulo Freire (1974) described as a "banking" system of education, which incorporates a fundamentally "narrative" character— the teacher as the transmitting subject and the students as the patient, listening objects (57).

Goodlad (1984) has shown that the reduction of teaching to telling, so common in U.S. classrooms, positions students as passive learners. Goodlad found classes in the arts to be an exception to this trend. In these settings, students did not learn solely through talk but also drew, painted, sang, acted, and danced, thus experiencing instructional transmediation for themselves and what it means to create knowledge and meanings through different modes of representation. This example shows that the assumptions that gave the study of language the privileged status in English and language arts classrooms over other ways of knowing— dance, music, art, visuals—no longer hold ground.

Textual Analysis, Narratives, and the Power of Transmediation

To appreciate what happens in the process of trying to interpret a text and the transfer of meaning between sign systems, let us consider, albeit briefly, what we might find in messages embedded in a newspaper article. As a mass medium, the newspaper plays a crucial and often decisive role in the construction or destruction of images of other people, places, religions, and nations of the world. Similarly, much of what teachers and students know about other peoples and places comes to them primarily in an array of prepackaged programs such as news, photographs, front-page articles, soap operas, sitcoms, features, commercials, talk shows, and most of all, textbooks. We often direct our attention to daily events and other matters in tandem with what the media choose to report or portray. In other words, we are not born knowing everything—what clothes to wear, what toys to play with, what foods to eat, which gods to worship, or how to spend our money or our time. In fact, the media continuously and in a multitude of ways represent to audiences, at the local, national, and global level, issues that are concerned with how people of different backgrounds and ethnic origins interrelate, clash, or live in harmony. These representations may be of a documentary nature, part of the news and current affairs output, or advertisements. They may also be, most significantly, dramatic representations of a fictional or semi-fictional kind.

You will also find that images rarely appear without the accompaniment of a linguistic text of one kind or another. For instance, a newspaper photograph will be surrounded by a title, a caption, or a story. It will also be situated within the context of a particular newspaper or magazine. The context provided by the *Los Angeles Times* is very different from that provided by the *Centre Daily Times* or the *Collegian*. Readership and audience expectation form part of this context, too. Keeping this context in mind and making it an object of analysis of media texts is an important step toward transmediation. When a learner moves from one sign system to another (as is often the case when analyzing media texts), semiosis (which simply means the cooperation of three subjects, such as sign, its object, and its interpretant) becomes even more complex because an entire semiotic triad serves as the object of another triad and the interpretant (which is another sign translating and explaining the first one), for this new triad must be represented in the new sign system (Eco 1976, 15).

Consider what happens when learners draw their interpretations of a written text, whether it be a story or an expository piece. They must arrive

at some understanding of the content and then find some way to cross the boundaries between language and art such that their understanding is represented pictorially. It is in this sense that one sign system is explored in terms (mediation) of another; hence, transmediation (see Chapter 3 for a discussion about children as symbol-makers and symbol-users).

As explained by Stuart Hall (1980), the mass media use readership and reader expectation to manipulate familiar sign systems to connect the authors/producers with the readers/viewers or audiences. Readers and viewers learn and relearn the signs until they become part of their environment or the acceptable convention of transmitting information. Thus, audiences are able to move from a denotative level of understanding of a sign to connotation. What makes the move from denotation to connotation possible is the store of social knowledge (a cultural repertoire) from which the reader/viewer is able to draw when he or she reads the image. Without access to this shared code (consciously or unconsciously), the operations of connotations (concept maps) would not be possible. And of course such knowledge is always both historical and cultural—a concept that is avoided by the neoconservative reformers of education. As Saussure argued, the relation between denotative signs and connotative signs (signifier/signified) that is fixed by our cultural codes is not permanently fixed. The meanings of words shift. The concept (signified) to which audiences refer also changes historically, and every shift alters the conceptual map of the culture, leading different cultures at different historical moments to classify and think about the world differently. Cultural difference might also be marked by differences of class, race, and gender. Thus, a study of the semiotics of representation of race within the framework of critical media literacy makes possible a deeper analysis of racial difference and leads to clearer understanding of how meanings are maintained or how they might distort rather than illuminate reality.

References

Apple, M. 1993. *Official knowledge: Democratic education in a conservative age.* New York: Routledge.

Barthes, R. 1974. *The elements of semiology.* London: Cape.

Berghoff, B. 1993. Moving toward aesthetic literacy in the first grade. In *Examining central issues in literacy research, theory and practice,* edited by D. J. Leu and C. K. Kinzer. Chicago: National Reading Conference.

Blumer, H. 1969. *Symbolic interactionism: Perspective and method.* Englewood Cliffs, NJ: Prentice Hall.

Bunn, J. 1981. *The dimensionality of signs, tools and models.* Bloomington, IN: Indiana University Press.

Cassirer, E. 1975. *An essay on man.* New York: Academic Press.

Culler, J. 1976. *Saussure.* London: Fontana.

Eco, U. 1976. *A theory of semiotics.* Bloomington, IN: Indiana University Press.

Fiske, J. 1989. *Understanding popular culture.* Boston, MA: Unwin.

Fiske, J., and J. Hartley. 1978. *Reading television.* London: Routledge.

Freire, P. 1974. *Pedagogy of the oppressed.* New York: Continuum.

Goodlad, J. 1984. *A place called school.* New York: McGraw-Hill.

Guiraud, P. 1975. *Semiology.* London: Routledge & Kegan Paul.

Hall, S. 1980. *Culture, media, language.* London: Hutchinson.

Hall, S. 1997. *Representation: Cultural representations and signifying practices.* Thousand Oaks, CA: Sage.

Hawkes, T. 1977. *Structuralism and semiotics.* Berkeley, CA: University of California Press.

Kellner, D. 1995. *Media culture: Cultural studies, identity and politics between the modern and the postmodern.* New York: Routledge.

Mead, G. H. 1938. *The philosophy of the act.* Chicago: University of Chicago Press.

Morris, C. W. 1971. *Writings on the general theory of signs.* In T. Sebeok (ed.), The Hague: Mouton.

Pailliotet, A. 1999. Deep viewing: Intermediality in preservice teacher education. In L. Semali and A. Pailliotet, *Intermediality: The teacher's handbook of critical media literacy.* Boulder, CO: Westview.

Pierce, J. R. 1961. *Signs, signals and noise: The nature and process of communication.* New York: Harper and Row.

Sebeok, T. 1976. *Contributions to the doctrine of signs.* Bloomington: Research Center for Language and Semiotic Studies.

Semali, L. 2000. *Literacy in multimedia America.* New York: Falmer.

Semali, L., and Pailliotet, A. 1999. *Intermediality: The teachers' handbook of critical media literacy.* Boulder, Co.: Westview.

Short K. and J. Harste. 1996. *Creating classrooms for authors and inquirers.* Portsmouth, NH: Heinemann.

Short, K., G. Kauffman, and L. Kahn. 2000. I just need to draw: Responding to literature across multiple sign systems. *The Reading Teacher* 54, no. 2: 160–171.

Siegel, M. 1995. More than words: The generative power of transmediation for learning. *Canadian Journal of Education* 20, no. 4: 455–475.

Suhor, C. 1984. Towards a semiotics-based curriculum. *Journal of Curriculum Studies* 16, 247–257.

Volosinov, V. N. 1985. Verbal interaction. In *Semiotics: An Introductory Anthology*, edited by R. Innis. Bloomington, IN: Indiana University Press.

Von Uexküll, J. 1940. *Theory of meaning.* New York: Seminar Press.

Vygotsky, L. S. 1962. *Thought and language.* Edited and translated by E. Haufmann and G. Vakar. Cambridge: MIT Press.

Zeichner, K., and D. Liston. 1996. *Reflective teaching: An introduction.* Mahwah, NJ: Lawrence Erlbaum Associates.

Chapter Two

Professing Transmediation but Transmediating Hardly Ever

Judith Fueyo

It is a time of high-stakes standards in classrooms across the United States and huge curricular compromises by teachers whose work is manipulated by outsiders. It is a time that undermines the very reasons many of us entered teaching: to position learners to be meaning-makers, to enable learners to shift the conventional power relations in schools and become co-participants in curriculum planning, to create knowledge and evaluate what they know. And be energized and competent enough to begin the cycle again.

It is a time when conversations about transmediation seem both frivolous and crucial. Frivolous because high-stakes testing environments make us control freaks. If "they" will test us, then we had better give them what they want, no matter what the cost to teacher energy or student spirit. Crucial because—that explanation, I hope, is the gist of what follows.

For longer than I want to admit, I've wondered whether it's worth destroying another tree to continue the conversation yet one more time. I've agreed to do so because I am not in a minority in what I know and believe. If you're reading this book, you know, at some level, everything I do.

The conversation is in three parts. The first asks why teachers and students should bother to buck the system and create classrooms where transmediation is standard procedure. The second part of the conversation asks what conditions enable transmediation to thrive. And the last asks how to name and assign value to transmediations.

Transmediation means the act of translating meanings from one sign system to another. Typically, in English language arts classrooms, this means inviting students and teachers to respond to printed texts in a range

of sign systems: art, movement, sculpture, dance or music, for example.
(See Harste, Woodward, and Burke 1984; Siegel 1995; Short, Kauffman,
and Kahn 2000.) For my purposes here, I want to focus on my own expe-
riences of moving from a verbal world to a visual one. I hope my story
illustrates both tangible and intangible features that help to make trans-
mediation part and parcel of how we do English language arts.

Why Transmediations?

Why bother to cultivate a classroom, especially a language classroom,
where students and teachers are invited to make meanings in alternative
media? To the idealists, I'd argue that it is right. To the pragmatists, I
would say "Because it's useful." Democracy promises everyone the right
to think and be heard. Maxine Greene (1988) claims that we fail to edu-
cate for freedom when we limit the range of symbol systems in our class-
rooms. Consider the thinkers and thoughts we will silence if we continue
to privilege words and numbers. Einstein envisioned his theory of rela-
tivity in dream images before arriving at numbers. Isadora Duncan,
famous choreographer of modern dance, when asked by a critic what a
certain dance piece meant, replied, "If I could tell you what it is, I would
not have danced it" (Gardner 1983). Linguist Michael Halliday (1975)
says rather than ask what does this student know, ask how many ways are
available for this child to know.

When I taught high school English, the kids I feared for most, the
ones who were most alienated from classroom work, were the ones who
hung around the art room or the music room or the shop—the kids who
volunteered to repair my old Chevy but wouldn't pass my test, the kids
who enlisted in the service to get out of school. I have often wondered if
things might have been different if only I had known ways to do things
differently. When I taught elementary school, I wondered how to name
and value Stephen's kinesthetic gifts: in first grade, he didn't just want to
read and write about planes. He was a plane! (See Fueyo 1989.)

Why bother inviting transmediations? Because democracy will suffer
if we don't. Because the life force will be snuffed out in both us and our
students if we don't. This need to make sense of experience in alternative
media knows no age limit. Recently, a colleague came to speak to my
evening doctoral class about qualitative research. She entered our class-
room and directed us to follow her. All fourteen of us paraded down the
university corridor to a smaller room. We entered to dimmed lighting;
candles; incense; an oval table set lavishly with homemade desserts,

drinks, appetizers; and Latin music. Off to one side was a little table set up with a photograph, flowers, and an ancient Peruvian document, one meaningful to my colleague because it was part of her country's liberation.

She invited us to experience the reading assignment on qualitative research from inside a rich environment, one that kindled emotions, images, memories, tastes, and aromas—much as qualitative research does. Only after we had shared food and talk did she ask us to respond to the assigned readings. Some of us wrote poetry, some drew, one wrote music, some cried. It is likely that most of us were moved to meanings different from what we might have made back in our regular classroom environment. What struck me most was the humanness of the evening. Seasoned graduate students were stunned to experience such an evening in a university classroom. Several admitted to a deep sadness, which is not typically content material in ordinary academic circumstances; sadness due to their poverty as students, their homesickness, the workload that eroded personal lives. All of us agreed that schools need to make a place for the whole human being and to provide alternative ways for each of us to participate.

I doubt these meanings would have come to the surface had my colleague proceeded in a traditional fashion: have students read the material, write a response, and talk in a group. Instead she engaged all our senses—smell, taste, hearing, vision, touch—because she knows these are sources of mediated knowledge. New understandings happened within an environment designed to elicit them. While I will not claim that this environment was responsible for the evening's transmediations, I will say that the variety of genres and meanings we produced were atypical in my experience. Clearly, classroom teachers aren't positioned to design exotic environments every Monday. But what can you do?

My Story

To provide the context for the second part of this conversation, I'll tell a story of my recent year's sabbatical, during which I left my university world and entered the oldest arts community in the United States, in Provincetown, at the tip of Cape Cod, Massachusetts. I joined this world of painters, sculptors, writers, and dancers specifically to become an insider in different symbol systems. I needed to put my money where my mouth has been for so many years, professing transmediations but transmediating hardly ever. Even though I've spent a professional lifetime

advocating meaning-making in alternative media and even though I've been active in community theater, I never stopped to analyze from inside the conditions that support transmediating.

I invite you to think alongside me all the way, imagining how your classroom might enable bits and pieces of what I experienced. You might complain that I experienced art learning/thinking and that this is not a priority in your curriculum. I would answer that any symbol system that upsets conventional thinking, that compels attention and invites new thoughts, is worthwhile investigating in any subject domain. I would hope, too, that aesthetic experience is valued for its soul-filling power. Not all thinking in school need be logical thinking.

By now, some readers might be shouting, "Dream on. Get real!" It is with full knowledge that I ask you to dream on to engage that willing suspension of disbelief we English language arts folks are so good at. Imagine yourself in control of what could be in your classroom. Wonder along with me why we tolerate standards that never mention wonder, flow, immersion, insight, joy, and rarely even democracy. That aspect of joy I mean is the one Noddings (1984, 132) calls affect, not emotion. For Noddings, affect is "the conscious subjective aspect of experience." Such a distinction between affect and emotion emphasizes the cognitive reflectivity involved in the joyful experience. I call this "cognitive joy" (for a discussion of this, see Fueyo 1990, 66). Market-based curricula goals remain deaf to these ideas, even though their absence threatens our quality of life more directly than an absence of many qualities the standards promote. Some of our own writing workshops lost the very conditions they were designed for: sustained time to do what writers do—write. The farther from the 1990s heyday of "writing process" we get, the more these ideals appear to deteriorate.

I became a member of two painting workshops, one representational, one abstract, at the Provincetown International Art Institute. Between the two classes, I spent two whole days in workshops in P'town, as locals call it, and the rest of my time was divided between painting at home and visiting museums and galleries on the Cape, in Boston, and in New York City. I consider my experiences "transmediations" because I read, write, and talk for a living; here I had to think visually. Whether our "subject" was a live model, a beach scene, or an imagined situation, I had to silence my habitual in-head monologue and create visual metaphors.

I continue to defend the need to enter a visual world as an insider. Keep in mind that my purposes for this arts sabbatical were to experi-

ence meaning-making in other media and make connections to my language arts practices. Consequently, part of me attended to the work at hand—I got comfortable in the sand and painted that beach scene. Part of me attended to how the artist-instructors designed the environment for visual thinking. And part of me fought to tame that interior monologue that labeled the whole venture too artsy, too removed from language arts standards, too enjoyable.

What Conditions Enable Transmediations?

What conditions best enabled transmediation in my experience? During my year-long immersion in this arts community, the conditions can be described within three domains. I've named them: place/tools, instruction/immersion/pace, and community.

Place/Tools
An entire workshop space existed for us during, between, and after classes, as well as on Saturdays. In addition to this space, we were told to make a permanent space where we lived, even if it be a corner, where we could leave our materials set out. The message was that artists work every day. Make conditions such that you can do your work. We were instructed to get specific kinds of papers, paints, brushes, gel pens, scrapers, mediums, wood frames, canvas by the yard, sponges, a few books, a carpenter's tool box, a journal, a library card, an Internet connection, and to beg, borrow, and steal rags. At our disposal were hammers, heavy-duty staplers, electric and hand saws, a printmaking press, etching materials. Occasionally live models were our subjects other days we were asked to interpret a personal emotion or memory or to respond to a video or a reading. On certain days we were invited into our painter-instructor's workshops in their homes, where we built canvases and noticed the ways of their work life.

But these are just the surface features of what I call place/tools. To give you a picture of the intangibles, envision a walk down the east End of P'town on any early fall day. Painters compete for space along treacherously narrow Commercial and Bradford Streets. Galleries and the historic Provincetown Art Association and Museum beckon for your attention—"Come in, look around. Wonders to behold." And then there is the light. P'town is famed for light unlike any other save the south of France. Perhaps it's the geography. P'town is one mile wide and three

miles long, about an hour and a half from Boston (see Figure 1). Only in
P'town can one watch the sun both rise and set over the Atlantic.

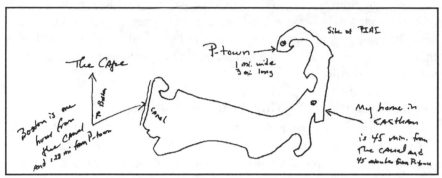

Figure 1: Map of Cape Cod

Whatever the reason, the atmosphere, the fog, and the hours between
4 and 8 p.m. are magical. Air, water, buildings, towers, even faces are
transformed. The impossibility of naming this phenomenon is why
painters come and paint.

Stop anywhere—the hardware store, the clam shack, McNulty's
Grocery—and you are likely to overhear artists talking shop: sculptors
boasting a great haul at the dump, painters trading tips on sales on paint
or canvas. Everyone, it seemed, was looking for a cheaper rent and a sale
on steamed mussels. On Tuesdays and Fridays many rushed to get *The
New York Times* because that's when the art reviews come out. Indeed, the
geography of P'town is emotionally, artistically, and economically con-
nected to New York City. One very long class day, we took a bus trip to
the Metropolitan Museum of Art and any other museum we could fit into
our eight hours in that art mecca. (For a treatment of how the lives and
times of creative people interact, read or see *Picasso at the Lapin Agile*,
a 1996 play by Steve Martin.)

The category of place/tools, then, represents more than I had imag-
ined. How rarely I've provided for my own workshops a comparable
breadth and depth of the tangible and intangible qualities above.

Instruction/Immersion/Pace

The P'town artist-teachers taught by example. They earned their livings
from their artwork, some of which was in galleries in New York City or
Arizona, and some of which was in local galleries. They were artists first,

teachers occasionally. They told stories frequently, sometimes of the work they had to do to support their art, most times of the decisions necessary to sustain their creative lives. I learned that to do good work, the artist works every day. Marriages or partnerships can suffer. A huge part of the work is negotiating lives around one's art.

Some days we looked at art books before and while we painted. Other days we watched as the instructor demonstrated a technique or continued his work in progress. Some days there was talk among us students, but most days we talked very little. Not because we were not friends, by any means. We were different ages and genders, from all over the country, and many of us made lasting friendships. But we talked only occasionally because we were somewhere else mentally much of the time. I recall one day a student came in late because she had attended a funeral. One student began asking questions, then another. Soon this latecomer asked, "Could we not talk? I come here to work in peace." Perhaps she was sad, perhaps grouchy. It doesn't matter, really, because what she expressed was something I'd felt but not articulated. The quiet was palpable, and what we were doing in it deserved respect.

Of course, I learned as much from classmates as from the teachers. From Emma, I learned that the direction of one's brush stroke mattered, from Eve that early work is an unreliable predictor of what's to come, from Keri that the palette knife paints more boldly than the brush, from Tim that what I feel matters more than what I see, from Harriet that you can make a mess and throw it away, from Donna that how you compose your subject is as crucial as how you paint it, from Tim that it's okay to admit that you want to be great, and from John that if you paint morning, noon, and night, no matter the cost of the paints and canvases, you'll produce some quality work. From each of them I learned how variously we see the world. Despite painting "the same subject," we painted dramatically different works. Given a live nude model as subject, for example, one woman student saw violence against women——her pose and background suggested blood and fear; one male student saw sensuality, sexuality; I saw a shape I thought I was supposed to "copy." Only later during the semester did I understand how interpretation is critique and that to copy is banal when one is doing serious art. One of our teachers described his process in any painting: he imagines what he sees is a moment in a scene and he tries to interpret previous and future emotions on canvas.

Because the point of all this is to critique the world, I was embarrassed to tell folks that in the spring I enrolled in an evening watercolor

class offered by the local continuing education department. Not because watercolor is less than acrylic or oil, but because our subjects were back-yard flowers and lighthouses. Real artists cause trouble. Upset expectations. Leave viewers thinking. I had yet to get to this place, but at least I knew it existed. How like writing this painting thing seemed at times!

My forty-minute drive to class each morning and evening trans-formed from the beginning to the end of my time in P'town. Remember, I'm a word person. When I drive, I listen to books on tape, local talk shows, show tunes, or I talk to myself. But by mid-September, I began seeing even the road ahead and in my rearview mirror as possible paint-ings. Instead of verbalizing in my head, I was seeing shapes and colors. I'd entered a different meaning universe.

I was transfixed by the disappearing road ahead, that vanishing line I'd been taught to see, and mesmerized by the color of a sunset that threw beach grass into pitch-black relief. I swerved off the road to photograph road signs, mailboxes, a dead seagull, and a lady who looked like a town character. (Not *THE* town character; P'town has many!) She biked down Commercial Street à la Annie Hall, floppy hat and fake flowers streaming in her wake. This behavior from me, a mother who rarely remembered to snap pictures of her three beloved daughters and who never once ordered class pictures.

What I want to convey here is the breakthrough from words to colors and shapes, a different way of perceiving my world, and why. These transmedial perceptions were enabled especially by immersion. For the first time I "saw" the artwork on my Matisse coffee mugs, "saw" the sun-light's tricks on the Eastham Windmill. I went to sketch it one morning, returned to finish late afternoon, and it was gone (see Figures 2 and 3).

Oh, the windmill was standing there, but it was an entirely different thing. I had to wait until another sun-drenched morning to capture what I first saw and wanted to "say" in paint. By late fall, I began to see human gesture as potential meaning for a portrait. I wanted to capture the rela-tionship between a habitual stance and personality. (For ideas on how to capture this in your writing workshop, see Karen Ernst 1994.)

My life was divided between doing art and thinking about doing art. I began to revise paintings in my head at night just as I do with my writ-ing. Indeed, I found most attempts to write about my art-making impos-sible. It felt as if I was threatening the very universe I was trying to inhabit. Immersion allowed verbal thinking to quiet down and visual thinking to come into play. My painting was improving only modestly

and irregularly, but my attention in the world was qualitatively different. I was seeing/thinking differently, even if the difference had yet to be achieved on canvas. (See Lave and Wenger 1991, for a compelling description of "situated learning" and what "legitimate peripheral participation" means for learning.) I thought a lot about kids who seem highly engaged in class but whose products don't reflect that. Could it be that evaluations are deficient, not the kids' work?

Then, in late November, I pooped out. I was exhausted. I was frustrated. I couldn't paint. I whined to everyone in earshot about how badly my paintings were going. So I stopped and got into Thanksgiving, rallied a bit into early December. Then, again, I felt done. Everything I touched turned to mud. I had filled myself to overflowing and needed time for things to settle, I guess. No one else seemed to behave like I did. But I gained a keen appreciation for students who run out of steam before the end of a term. By whose clock do we set learning? (See Lofty 1992, for an argument against the artificial time structures we've institutionalized in writing workshops.)

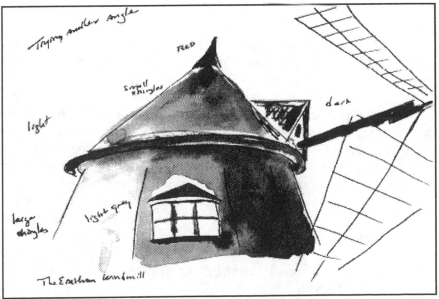

Figure 2: Sketch of Eastham Windmill

Figure 3: Preliminary Sketch of Jane

Community

It would be redundant to develop much further the significance of community in this arts environment. I hope I have woven it throughout. Still, two things might add to the description. The first is the power of transmedial experiences: I was seeing the world through my fellow artists' eyes and was profoundly moved by their distinctly different visions. The second is the final art show. All of us turned in our best work, and it was hung professionally in the Provincetown Art Gallery and Museum. The event was advertised, a classy array of wines and finger food was set out for us artists and the several hundred viewers, and we critiqued and celebrated our own and each others' creations. We were artists, and part of the larger arts community. And so it was from day one. The last question of this three-part conversation asks: How can students . . .?

How Do Students and Teachers Evaluate Transmediations?

In a previous article, I've argued for qualities in transmediations that connect with specific literate benchmarks. I called these "literate sensibilities" (see Fueyo 1991). Now I am arguing more explicitly for a

comprehensive valuing, such that not only literate growth but also whole human growth is up for grabs, as is our democracy.

I invite you to temper your concern for standards and allow Dewey (1934) to defend you. If only we'd stuck with Dewey, we might have avoided this argument altogether. In *Art as Experience*, my favorite book by an educator for educators, Dewey analyzes ways to assess works of art. He makes the distinction between standards and assessment. To begin, a standard has three characteristics: "It is a particular physical thing existing under specified physical conditions; it is *not* a value." The yard is a yardstick, and the meter is a bar deposited in Paris. In the second place, standards are measures of definite things, of lengths, weights, capacities. The things measured are not values. Finally, as standards of measure, standards define things with respect to quantity (1934, 307).

Learners' transmediations are a lot like works of art: they require conceptualizing an idea or problem-posing and interpreting it in a public way. They require degrees of knowledge of various field or discipline techniques, values, ways of thinking and seeing and being in the world (Gardner in Feldman et al 1994). They require a respect for intentions and experience. They invite a critical view of the world and they demand critique of the student/artist/s product.

To insist on standards that miss what might be yet unnamed, even unimaginable qualities possible in transmediations, is dysfunctional. Like Dewey, Eisner respects the unknown potential in alternative ways of knowing and warns us that the kinds of nets we cast predict the kind of fish we catch. Eisner (1998, 179–181) explicitly criticized national standards: "In a nation in which 45 million students in 50 states go to approximately 108,000 schools overseen by some 15,000 school boards and in which 2.5 million teachers teach, there is the presumption that it makes good educational sense for there to be uniform expectations with respect to goals, content, and levels of student achievement." He reminds us that to criticize national standards is not to abandon aspirations for high levels of achievement. Quite the contrary. By supporting different ways of knowing and different kinds of knowledge, we maximize meaning potential and cultivate wonder.

If not national standards, what then? Below I offer some criteria I've found flexible and sensitive when naming and valuing features of transmediations. My students have used them too and seem surprised by the fit between these descriptors and what they and their students produce and

Fueyo, Judith. 1990. *Playful literacy: First graders as meaning makers in the literacies of play, the creative arts, and the language arts*. Ph.D. dissertation, University of New Hampshire.

Fueyo, Judith. 1989. One child moves into meaning—his way. *Language Arts* 66: 137–146.

Gardner, Howard. 1983. *Frames of mind*. New York: Basic Books.

Goodman, Nelson. 1968. *Languages of art*. New York: The Bobbs-Merrill Company.

Greene, Maxine. 1988. *The dialectic of freedom*. New York: Teachers College Press.

Halliday, Michael. 1975. *Learning how to mean*. Wheeling, IL: Whitehall.

Harste, Jerome, Virginia Woodward, and Carolyn Burke. 1984. *Language stories and literacy lessons*. Portsmouth, NH: Heinemann.

John-Steiner, Vera. 1985. *Notebooks of the mind: Explorations of thinking*. Albuquerque, NM: University of New Mexico Press.

Lave, Jean, and Etienne Wenger. 1991. *Situated learning: Legitimate peripheral participation*. New York: Cambridge University Press.

Lofty, John. 1992. *Time to write: The influences of time and culture on learning to write*. Albany, NY: SUNY Press.

Martin, Steve. 1996. *Picasso at the Lapin Agile*. New York: Samuel French, Inc.

Noddings, Nel. 1984. *Caring: A feminine approach to ethics and moral education*. Berkeley: University of California Press.

Short, K., G. Kauffman, and L. Kahn. 2000. I just need to draw: Responding to literature across multiple sign systems. *The Reading Teacher* 54, no. 2: 160–171.

Siegel, Marjorie. 1995. More than words: The generative power of transmediation for learning. *Canadian Journal of Education* 20: 455–475.

Chapter Three

Transmediating in the Classroom: Implementing Critical Literacy in Elementary Grades

Mary Napoli

Like most good ideas in teaching, this one came from a student. While walking to the office from my first-grade classroom, I noticed Gabriella puzzling over a small booklet. I stopped to talk with her and found the text to be a Barbie magazine, the kind one finds stuffed in the back of a doll box. Gabriella told me that she was curious about why Mattel only made clothes that no one she knew would wear. At that moment, I realized that my literacy program wasn't challenging enough for my students.

Like most first-grade teachers, I was schooled to offer developmentally appropriate literary practices for my students. But here was Gabriella, right in front of me, asking a most profound question that focused upon issues of gender, commercialization, and culture. In my teaching, I was offering opportunities to read the word, when Gabriella was already using text to read the world. This experience sent me on a two-prong journey; the first was to explore what other students in my class could do with text and the second was to search for ways to integrate this type of exploration within my curriculum.

It is still early in September, and the leaves are slowly changing colors outside the old wooden windows of the classroom. Twenty-four first-graders sit expectantly around a soft carpeted area waiting for the opportunity to share and to listen to the daily read-aloud selections from our favorite book box. Robert, our group meeting committee leader, focuses the group with an open-ended question. "Well, guys, don't you think it's time to share some stories?" Heads nod in agreement. Gabriella begins to talk about the Barbie-magazine insert with the group and says, "Look, I don't know about you, but the clothes that the doll is wearing are not what ladies wear back home in Puerto Rico."

"Well, Gabriella," says Harry, "I guess the people who make the dolls just never visited Puerto Rico. They probably think that all ladies around the world dress the same."

"Maybe," responds Julie, "but the people who make the dolls are supposed to know a lot. I mean, aren't they grown-ups?" Robert looks over to me for some help to mediate the discussion and I smile to assure him that he is doing just fine.

My plans for that morning included a read-aloud followed by a series of book discussion questions and the completion of a "must do" follow-up activity recommended in the curriculum guide. However, as I looked at this community of learners who were asking important questions that interrogated the world of print, I decided to ignore the plans. I acknowledged that they were raising very interesting points and that there were other types of advertisements that would generate similar debates.

These ads were from the back-to-school sales and were sponsored by major department stores found in many suburban towns. The headings of these brightly colored inserts remind readers that the summer days would soon be over and that "learning" in classrooms would once again begin. The ads showed children of various ages and backgrounds wearing new outfits. These children were carrying backpacks advertising the most current Disney movie characters as well as lunchboxes, thermoses, and even folders. The ads also contained pictures of material items such as snack packs, crayons, markers, and small toys. Before the children got to view the ads, I asked them to draw and label (using temporary spelling) items that they would expect to see in a back-to-school ad. The students drew pictures of lunchboxes, book bags, shoes, new pants, and a variety of toys, including Barbie.

Students were also asked to illustrate items that would not appear in these ads. In order to allow the children to think more deeply about this phenomenon, they were invited to discuss who they thought the back-to-school ads were written for. Some popular responses included moms, dads, caregivers, principals, and teachers. Perhaps the most interesting part of the engagement included what I call an inquiry act (a question followed by an activity):

What do the back-to-school ads say about you as a child or student at school? How would you create a new ad, which shows what is really important to you about being in school?

Although this might sound difficult for young students, my experience working with this group confirmed that I should not underestimate

their understandings. I believe that the human gifts of perception and insight promote the exploration of our world. As one excavates a text for cultural conversations, one becomes an archeologist involved in a critical search beyond the ordinary finds. Therefore, by encouraging students to critically look at texts, a teacher invites students to become involved in this exploration. The students drew about such diverse topics as playing with friends at school, reading books, sharing new toys on the playground, and playing with popular toys such as Nintendo.

As I reflected upon this initial experience, I realized that my literacy program did not provide for opportunities to raise questions. Yet when I thought about where the children were coming from, the books that they were reading in schools, and the program that I was using, I did not see a solid connection to their world. I began exploring these issues further and became concerned that if I spent too much time on my students' questions, I wouldn't "cover" everything that I was supposed to. Then I stumbled upon an article written by Jennifer O'Brien (1994), a primary teacher in Australia who engaged students in text analysis. In her classroom, she provided many opportunities for her students to visually dissect Mother's Day catalogues and junk mail. She found that this intensive examination of the catalogues offered children an opportunity to consider a gendered cultural event and its connection with marketing and advertising (Comber 1993). In addition, Allen (1997) writes in defense of helping even very young students develop a critical and questioning stance in relation to texts, concluding that:

> If teachers assume that the students are unaware of bias in learning materials (and, one might add, in their literature as well) and there is no discussion around the issue of bias, then students will probably learn to ignore or deny the existence of bias in the materials and to accept passively the social meanings implicit in these materials. The danger is that students will internalize these values to such an extent that they become a lens through which they understand their world. Therefore, the lack of discussion about the social meanings contained in classroom learning materials may serve to perpetuate the status quo by training students to be passive, unquestioning, conforming citizens. (523)

Although these words resonated with my newfound beliefs and discoveries, I still had to face the realities of schooling and state mandates. I wondered how I could model questions about the world within the context of what I was required to teach. I thought about my beliefs about children in today's society and asked myself how educators can become

facilitators in helping children read critically in order to better and potentially change their world.

In today's world, a constant stream of visual images bombards children. As I continued to rethink my position, I decided that I needed to create spaces for my students to explore the relationship between the text, the author, the reader, and the world. Not only did I continue to encourage students to examine ads that included holiday inserts from Christmas to Valentine's Day, I also approached the sharing of children's literature from a critical perspective.

In my experience with teaching elementary school, I have noted that children's literature presents its audience with values approved by adult society and overtly or covertly attempts to justify and impose "correct" patterns of behavior. For this reason, I selected the issue of gender primarily because of its relevance to first-grade children. Despite the plethora of research reports on gender in children's development, many early childhood programs fail to include it in their scope and sequence.

Before children officially learn to read, they are already reading the world around them, and bringing to this process all the skills of taking meaning from context that they will later draw on in the reading of text (Pidgeon 1993). This notion is transferable to the gender bias that exists in the everyday world and incorporates power inequities between women and men. Gilbert and Rowe's (1989) study analyzed the ways in which male and female characters were constructed in a series of texts written especially for young readers. Not only did their research tabulate the ratio of male to female characters in books; it also examined how the world and the characters in these books were constructed. They theorized that the way girls and boys are constructed in and by society is mainly through language practices. This implies that classroom practices are socially constructed and that they can be examined, considered, and formulated differently.

Keeping this in mind, I decided to engage students in an activity to explore the gendered nature of texts by drawing their attention to the stereotypical construction of boys and girls. Research has indicated that classifying behavior into the category of girl or boy can influence choices in toys, playmates, activities, color preferences, and so forth. Information used by children to determine behaviors that are appropriate to males and females comes from a variety of sources that includes families and the media (Fagot 1982; Wellhousen 1996). I decided to engage my students in a conversation that would disrupt these notions and allow

them to identify themselves in both categories. The following chart illustrates the responses generated by my students when asked to describe specific characteristics identifying boys and girls.

Words to Describe Girls	Words to Describe Boys
Smart and nice	Play with action figures
Wear make-up, dress like supermodels	Have short hair
Cooks and takes care of family	Play sports like football
Beautiful and thin	Powerful and strong
Play with dolls	Rough and active

We then discussed whether or not the students would be comfortable if they were to apply some of their descriptions to the opposite gender. The following student dialogue illustrates the conversation among the students:

Kate: I don't think that the word strong should be just in the boy section.

Jasmin: Yeah! It sounds like only boys can be strong. Lots of girls can be strong too.

Robert: I think that you might have a point. Strong does not just mean to be able to lift heavy things.

Miss N.: So do you think that the word strong describes both boys and girls?

Kate: Yeah! I think that girls can be strong inside and outside just like boys.

Robert: Why do people think that boys have always to be stronger than girls are?

Miss N.: That is a good question. Let's discuss it. What are your ideas?

Angela: I think that some people get these ideas from movies. Lots of time the girl in the movie always acts weak. She waits for the boy to rescue her instead of figuring it out on her own.

Amanda: Yeah, and in books, like the fairy tales we have been reading, the girl always says stuff like, "Oh my hero" which sort of makes you think that the boy has to be stronger.

Robert:	I also think that the ads in the newspapers that we looked at do the same thing.
Miss N.:	So what do you think we can do about this?
Michael:	We could ask questions like we do when read books.
Amanda:	We could also get our parents to help. Lots of times my family and I talk about the books or movies that we see.
Miss N.:	Good ideas. Now what about this list? Do you think that we could put some of the words in both categories?

Immersing students in this activity led to a consideration of the connotations of certain words and how language constructs certain views of what it means to be a "boy" and a "girl." In the above transcript, it is interesting to note that the students' conversation stemmed from the comments suggested by their peers. Conversations with children reveal a powerful awareness. Even though some of the children did not agree with placing the word strong in both categories, listening to and appreciating what is being offered by children guide educators in our understanding of their world. The above example illustrates the students' ability to address issues of bias, discrimination, and inequality through specific experiences with multiple texts. Their prior experiences with messages conveyed in media and in print enabled them to acknowledge these issues and their implications. Moreover, Giroux (1998) indicates that students need to acquire the knowledge and skills to become literate in multiple symbolic forms so as to be able to read critically the various cultural texts to which they are exposed.

It was now January, and my classroom had become a safe harbor for these discussions to occur. I began to become more adept at finding ways to encourage students to explore the world of print both orally and in writing. As I continued to journal about my findings, I noticed many emerging themes which fit many of the objectives of the first-grade curriculum. That afternoon, I received a memo in my mailbox informing me that I was going to be observed by the district superintendent the next morning. As you can well imagine, I was nervous. I had been incorporating many of the stories from the required basal series in my teaching in addition to exploring alternative ways to analyze texts with children. As I drove home that afternoon, I decided that I wouldn't change my plans. The more I thought about the interrelationship that exists in the nature of texts, the more I reminded myself that by providing ample opportunities to examine print would assist students to construct critical interpretations.

The next day's sprinkling of snow seemed like a welcome metaphor for a glistening opportunity to continue the exploration, to immerse my students in discussions about the images and messages inherent in our language. As my students excitedly entered the classroom, the district superintendent walked in and made observations of the environment. The time had come to continue to utilize texts that would represent a variety of gender roles and to examine the language used in books.

Gender-biased language that implies that women don't have careers or make contributions to society and that men don't have nontraditional jobs or serve as caregivers is not appropriate (Wellhousen 1996).

Before reading aloud Anthony Browne's *Piggybook* (1986), I asked the children to share their thoughts about household jobs and encouraged them to consider if these correlated with typical gender stereotypes. The following diagram illustrates their responses:

Household Jobs Performed by Mothers	Household Jobs Performed by Fathers
Cooks meals	Takes out the trash
Cleans and dries the dishes	Fixes things in the house
Does the laundry	Mows the lawn
Goes shopping for food and clothing	Puts gas in the car
Cleans the house	Fixes the car

In addition to asking children to illustrate their mom or dad engaged in a "household" job, I also asked them to draw a picture of themselves depicting a job that they do at home. Their illustrations illuminated the research about how children organize information from their world based on gender, which, sadly, results in gender-role stereotyping. After sharing, the students saw plenty of alternative possibilities such as boys doing the dishes with their moms and girls taking out the trash with their fathers. Exploring these alternatives encourages children to go beyond gender-role constraints. Ignoring or perpetuating children's gender stereotypes has a documented negative effect on children, especially in the area of self-esteem and self-worth (Wellesley College Center for Research on Women 1992; Sadker and Sadker 1994).

The small sampling I have presented affirms that the critical analysis of texts is possible in a first-grade classroom. The examples reaffirm the necessity to involve students in book discussions that disrupt the notions

of traditional gender roles. I hope that other educators will revise and refine these ideas as they examine their curricula for opportunities to create and explore similar venues in their own classroom. This classroom research reinforces the importance of providing opportunities for students to examine the images in texts.

As I continue to learn more about critical media literacy, I look forward to exploring how my students can continue to take a critical stance toward the books that they read. I am aware that there are many other ways to incorporate critical literacy in my classroom in other areas such as writing and art.

I am also aware that many researchers have theorized about critical literacy. They postulate several different positions. For example, Allan Luke (1988) believes that our aim for critical literacy is to get students to construct and to challenge texts, to see how texts provide selective versions of the world with an eye towards transforming social, economic, and cultural conditions. Patrick Shannon (1989), however, sees critical literacy as a "means for understanding one's own history and culture and their connection to current social structure and for fostering an activism toward equal participation for all the decisions that affect and control our lives." Lankshear (1994) describes critical literacy as "analytical habits of thinking, reading, writing, speaking or discussing routine clichés; understanding the social contexts and consequences of any subject matter; discovering the deep meaning of any event, text, technique, process, object, statement, image, or situation; applying that meaning to your own context" (9).

Incorporating the key concepts of critical media literacy into my first-grade curriculum has been both challenging and rewarding. I believe that as an educator I have a responsibility to help students develop into caring and becoming responsible citizens. If I am to provide opportunities for students to shape their identities and confidence, then it seems necessary to invite them to raise questions that will help them make sense of their world. When my district superintendent visited he commended me for engaging children in conversations that will help shape their future. In fact, I was invited to attend future district curriculum revision meetings. I expect to continue to reflect upon my practice in order to create more opportunities for my students.

References

Allen, A. M. A. 1997. Creating space for discussions about social justice and equity in an elementary classroom. *Language Arts* 74: 518–524.

Browne, A. 1986. *The Piggybook*. New York: Afred Knopf.

Comber, B. 1993. Classroom explorations in critical literacy. *The Australian Journal of Australian Literacy* 16, no. 1: 73–83.

Fagot, B. I. 1982. Adults as socializing agents. *Review of Human Development*, no. 10: 304–315.

Gilbert, P., with K. Rowe 1989. *Gender, literacy and the classroom.* Carlton: North Australian Reading Association.

Giroux, H. 1998. *The mouse that roared*. New York: Rowman and Littlefield.

Lankshear, C. 1994. Critical literacy. *Occasional Paper* no. 3: 4–26.

Luke, A. 1988. *Literacy, textbooks and ideology*. Lowes. Sussex: Falmer Press.

O'Brien, J. 1994. Show mum you love her: Taking a new look at junk mail. *Reading* 28: 43–46.

Pidgeon, S. 1993. Learning reading and learning gender. In *Reading the difference of gender and reading in elementary classrooms*. York, Maine: Stenhouse.

Sadker, M., and D. Sadker 1994. *Failing at fairness: How America's schools cheat girls*. New York: Charles Scribner's Sons.

Shannon, P. 1989. The struggle for control of literacy lessons. *Language Arts* 64, no. 6. 625–634.

Wellesley College Center for Research on Women. 1992. *How schools shortchange girls: The AAUW report*. Washington, DC: American Association of University Women Educational Foundation.

Wellhousen, K. 1996. Girls can be bull riders, too! Supporting children's understanding of gender roles through children's literature. *Young Children* 51, no. 5: 79–83.

Chapter Four

Transmediating through Play and Art in the World of Children

Pei-Yu Chang

You have heard children say this before: "I just want to draw!" Or "If only I could show them how to draw what they read in literature," an English teacher might sigh. Children like to draw, play, and imagine things. But in the eyes of many parents and teachers who cling to an education transmission model of teaching children, play is not related to children's learning. To them, art may be regarded only as one of children's recreational activities. These teachers seem to think that play and art should not be treated in the same way as other academic subjects taught in schools. For those teachers who teach about arts, the devalued conceptions about play and art are a dangerous sign. Such negative conceptions reflect an attitude that stifles children's learning and partly accounts for some of the failure of education. Why should teachers and parents care about play and art? How can teachers make multiple symbol systems a part of the reading and writing curriculum?

In recent years, there have been signs that the negative trend is changing. In some quarters, play has been regarded as an essential element in early childhood programs mainly because of emerging evidence about its contribution to children's learning and development. During the 1990s, for example, news about using art as a learning tool for children by Reggio Emilia in Italy revolutionized the way educators view play and art in the world of children. As a teacher at Kid's Imaginative School in Taiwan, I heard the news about the work of Reggio Emilia. I recognized the importance of being a playful teacher in facilitating children's play. In my own teaching of young children, I was constantly reminded of the teachable moments that play and art can make in children's learning, particularly when the teacher played an active role as a

"playmate" and facilitator at the same time. Sometimes I provided the children with materials and supported their rich environment; at other times, I gave suggestions to them or pretended to play a role with them to enrich their play.

Participating in children's play was a very rewarding experience for me as a teacher. This experience was valuable not only because it allowed me to learn more about children's interests and potential but also because it helped me to understand children's learning processes. One of the things I learned from working with children was to recognize the relationship between children's play and art. I learned that play and art were vehicles that children used to learn and develop meaning for themselves. In my teaching diary, I recorded several such vivid vignettes of children's play. I like reading these play-vignettes from time to time because they inspire my teaching and enable me to gain a better understanding of children's lives. Here is one such play vignette.

> Fen-Fang said, "Ling-Ya, you be the dresser and teacher Pei-Yu be my daughter, ok?" "Ok, but I need an assistant." "How about Hsin-Yi?" "All right, but next time I would like teacher Pei-Yu to be my assistant." "Okay, let's begin."
>
> Lin-Ya was sitting at a table making several drawings of different kinds of dresses. Her assistant, Hsin-Yi, was cutting cloth to make dresses at another table. I followed Fen-Fang from the block corner, where we pretended to get out of the taxi and went to the place where Ling-Ya was working. Fen-Fang said to Ling-Ya, "Hi, Ms. Chen, I am coming back to see you again. I really like the dress you made for me last time for my birthday party. Do you remember?" "Of course, that's the work I am really proud of," Ling-Ya replied. Fen-Fang said, "This is my daughter Pei-Pei. [turning to me] Say hello to auntie Chen." "Hi Auntie Chen, you are really good at making beautiful dresses," I said.
>
> Fen-Fang talked to Ling-Ya, "This time I would like you to make a dress for my daughter because she is going to participate in the wedding of my sister." Ling-Ya replied, "No problem, just tell me what style you like. Let me do the measuring first." Ling-Ya left her seat and circled around me with a paper ruler on her hand as if she was measuring me for a suit. She jotted down some numbers on a piece of paper after the measuring step and then showed me a book of dresses in different styles. She said, "Pei-Pei, look through this book and choose the one you like. Also think about what color you prefer." I got the book from Ling-Ya and began choosing the one I liked.

As shown in this vignette, play and art are playful and enjoyable experiences to children. Furthermore, children's interests and confidence in play seem to grow consistently with the verbal narration that accompanies it, and both are enriched because of the playful context.

From this experience, I have learned that teachers can facilitate the playful learning of young children through the connection of children's play and art activities. Therefore, a careful reconsideration of the importance of both play and art for young children is necessary. In this chapter, I describe my work with children and the shared characteristics of play and art in children's lives. I provide examples to illustrate how play and art support and strengthen each other in a transmedial process in which meaningful learning is made possible. In the conclusion of this chapter, I mention examples from the United States, Japan, and Italy to reflect on how play and art can enrich children's language competency and literacy learning in the classroom by bridging a fragmented curriculum of different subjects into a comprehensive learning structure of an integrated curriculum.

Spontaneous Engagement in Play and Art

While examining children's play and art activities, I found that both activities are playful and enjoyable. The pleasures derived from play and art activities led me to ask, Why playful? Why is play important to children? Scholars have wondered about these questions for quite some time. Their explanations seem to suggest that play and art are enjoyable experiences because they provide avenues through which children's desires are satisfied, dreams come true, feelings and knowing are expressed, experiences are organized, and knowledge is constructed. Here is a summary of what these scholars think about play and art activities for children.

Pleasures
Play has long been regarded as an activity springing from children's innate nature. It is children's spontaneous and voluntary activity that gives them pleasure and joyfulness (Garvey 1990). Because of the happiness arising from play, children never tire of it, even if they are repeatedly involved in the same activities. The same feeling is experienced when children engage in art-making because it brings them enjoyment (Burns 1975). Children like to see the movement of their hands while drawing, the marks they make on the paper, or the different shapes of clay they make by pounding clay with different parts of their hands. These exciting findings relieve children's boredom (Wilson 1987). This explains why some children incessantly engage in drawing or some other artistic activities without tiring of the activities.

Fulfillment of the Future
When children are asked what they wish to become when they grow up, each child seems to have a different answer. Some want to be scientists, others want to be the president, still others want to be a mother. Children portray their future self through play and art. In dramatic play, the role a child would assume might tell the future role he or she would wish to fulfill. Thus, play gives a child the chance to imagine and simulate the future self. Likewise, a picture painted by a child or a sculpture modeled by children can suggest clues about their anticipation of their future self, the career they wish to follow, and their ideal life in the future. This is the "prophetic reality" acquired through play and artistic activity (Wilson and Wilson in press).

Realization of Dreams
Both play and art provide contexts for children to fulfill unrealizable dreams in the real world. Vygotsky (1973) believes that play is the tool children use to satisfy their desires. Such representational play conducted by children creates an imaginary situation to realize an unachievable dream (Berk 1994; Vygotsky 1973). For instance, a little girl can fulfill her desire to be a soldier by putting on costumes, guarding with weapons, and marching like a real soldier. Copple, Sigel, and Saunders (1984) indicate that dramatic play has so much appeal to children because it involves the "feeling of efficacy, the joy of making things happen" (183). Children also make their dreams come true through art-making. Through art, children create something to fulfill their wishes (Wilson 1987). For example, a little boy fulfills his hope to own a robot by drawing it and/or modeling it with clay. Another salient example is found in Wilson's study (1997) of Japanese children's drawings. Children in Japan draw Doraemon, an atomic-powered cat which has a kangaroo-like pouch from which he can produce anything his best friend Nobita wants or in which he carries Nobita anyplace he wishes to go. Thus, through drawing stories of Doraemon, children fulfill their dreams or wishes (e.g., a journey to an exciting place or solving a problem).

Satisfaction
Both play and art satisfy children's need to experiment with "normative reality," which is "the reality of good and bad, of right and wrong, of just and unjust, a reality of standards, subsuming the implicit and explicit rules by which an individual or a society behaves" (Wilson and Wilson in

press, 29). In play and art, as the child pretends to be a judge in dramatic play or portrays himself as a judge in a drawing, his or her understanding of "right" and "justice" are enhanced.

At other times, children like to explore the world opposite to the world of right and good. Although children are told to behave desirably according to adults' standards of what is right and what is wrong, sometimes they experiment with the normative reality by experiencing the feeling of being bad through play and art. In this case, both play and artwork are used as tools through which children explore what is inhibited by adults without taking any risk, and this gives them pleasure. For instance, in dramatic play, they can simulate the attitudes and behaviors of a criminal; in drawing, they can portray themselves as a carnivore preying on other animals.

Emotional Needs

Children may be confronted with conflict and anxiety because of biological differences (e.g., developmental delays or learning disabilities), internal problems (e.g., lack of self-confidence, and low self-esteem), and external factors such as traumas (e.g., divorce, abuse, etc.), pressures (e.g., academic competition), accident (e.g., separation from family members, loss of a body part, favorite animals, or family members), social and cultural changes (e.g., separation anxiety or an attachment problem, moving to a new city or a different culture), and so on (Clark 1995). It has been shown that both play and art are invaluable to children in resolving anxieties and fears and coping with anger and concerns derived from the events in real life. Play is the best tool for letting children act out their feelings, release their emotions, and thereby solve problems (Johnson, Christie, and Yawkey 1999). Like play, art is regarded as a good medium for people to express their feelings. For the young children whose language development is not complete, art can be used to compensate for verbal limitations (Clark 1995; Muri 1996). The merit of using play and art as tools for externalizing their internal emotion is that it prevents children from transferring their anger to others (Landreth 1993). In addition, both art and play are vehicles for sublimating sexual expression (Wilson 1976). Hughes (1995) has shown that children's symbolic expression in play reveals the conflict of sexual aggression in life (Hughes 1995). Likewise, art provides children with "a safety valve for the expression of that which is tabooed" (Wilson 1976, 52). The example given by Wilson was a little girl's drawing with sexual themes.

Knowledge Construction
Children play to know and to learn. Play is the primary tool children use
to explore the surrounding environment and to construct their knowledge
(Eisner 1990). From Piaget's constructivism we learn that children's
interaction with the surrounding environment is the main resource for
knowledge construction. Through play, children's desire to know what
they wonder about is satisfied, and by doing so, their knowledge is
increased. For instance, children play seesaw and explore with scales
because they are curious about the situations of balance and imbalance.
After several explorations, they understand the concept of balance and
how it relates to weight.

The same function, knowledge construction, is shared by children's
art. Franklin (1994) claims that through art children construct knowledge
about the world. Wilson and Wilson (in press) state that drawing is a way
children know about the world and construct their knowledge. For exam-
ple, children in the Reggio Emilia school in Italy used multiple art media
to understand a specific concept in order to acquire deeper understanding
of it. For instance, in order to understand how a waterwheel works, a boy
used it in different ways to maximize his knowledge about it, which
included drawing, sculpting paper, with clay modeling, and building a
wood waterwheel with coil loops (Forman 1996).

Expression and Communication
Both play and art are like the language children use to express ideas, feel-
ings, and understandings about the world (Balke 1997; Eubanks 1997).
Norton and Norton (1989) have referred to play as the language of chil-
dren and to toys as their words. Children's representation of thinking and
feelings are revealed in their construction and manipulation of toys and
materials to form images that are transmittable to others. For instance,
building a castle with big wooden blocks is a way of expressing a per-
ception of a castle that can be shared with others. Likewise, art is the
vehicle children frequently use to express themselves and to make others
understand what they think or intend to express through drawing, paint-
ing, or manipulating clay (Kolbe 1993). Young children frequently use
drawing as a tool to describe what interests them. For instance, with
papers and crayons or markers children can draw a favorite person or an
unforgettable trip taken during summer vacation (Maitland 1985).
Graphic representations of this kind sometimes stimulate language use or

oral communication, such as telling a friend what was impressive in the trip portrayed through drawings (Kellman 1995).

Organization of Experiences
One of the purposes for children to engage in art making or in play is to organize their experiences (Franklin 1994). It is frequently found that a child plays with miniature cars or figures to perform what happened during the weekend or in a journey to the zoo. Thus, play gives children the chance to "replay and record experiences" (Johnson 1990, 213). Through the process of replaying their experiences, children organize events in chronological order. The following vignette illustrates how a little girl demonstrated deferred imitation in play, and through it, organized her experience chronologically:

> Amy is simulating herself as her teacher, and in this simulation she is asking her mother and two aunts to be her students. She is trying to replay an activity that was held at school. She talks to her students: "Hi, little friends. Today we want to practice the dance I taught you last week." While talking, she is directing her students to the pretended stage. After all her students are standing where they are supposed to be, she positions herself in the place her teacher used to take (facing her students) and shows her intention to begin the dance, by hiding her hands behind her. Suddenly, she finds out that she has forgotten one step before the dance so she stops her body actions and says, "Oh, no. I forgot to turn on the music. The teacher has to turn on the music for the dance."

As shown in this vignette, for children, order is their main purpose in making play and art. That is, through art they "organize and image their thoughts and feeling about the world of experience" (Smith 1982, 297).

Wilson and Wilson (in press) remind us that children draw what is "common reality" to them; that is, they draw things and events that are familiar to their daily life perceptions and experiences. This observation resonates well with my own experience of making a drawing as a child. Drawing was an example of how I organized my experience. To this day, I remember a map I drew that clearly depicted the route from my house to a clinic to see a doctor. After I finished taking the injections and medicine from the doctor, my mom rewarded me by taking me to a store to get candies. Thus, on the map, I put a big mark denoting the important place (the candy store) where I got candies. After completing the map, I showed it to my parents. I explained to them how to follow the directions on the map. The opportunity to make a map and explain it to my parents helped me reorganize my experience of the trip to the doctor's office.

Drawing the map helped me to be clear (the candy store was on the oppo-
site side of the clinic) and to imagine the events that transpired. As with
play, the act of drawing gives children, like it did for me, a chance to
revisit and represent past experiences. For young children, replaying and
drawing past experiences from memory gives them the chance to recall
their experiences and help them to understand themselves and the world
around them more fully (Smith 1982).

Transmediating through Play and Art

As explained in Chapter 1, the process of transmediation takes under-
standings from one sign system and moves them to another in order to
make meaning (Siegle 1995). By sign systems, I mean multiple ways of
knowing—the ways in which children share and make meaning through
talk, play, singing, and art. As will be explained later in this chapter, some
scholars who observe children's play refer to those children who com-
municate in these multiple ways as symbol-creators, symbol-makers,
symbol-weavers, and symbol-users (Dyson 1990; Kolbe 1993). It is
through these multiple uses of symbols that children are said to transme-
diate through play and art. For example, as part of their play, children use
many signs and symbols as they draw and narrate or talk about their cre-
ative work.

Perhaps the relationship of the many symbols and signs used in art
and play could be examined through the process of art creation and
through the artist. As articulated by Fueyo in Chapter 2 of this book,
artists and designers frequently describe their creative procedures as
"playing around and toying with ideas." Artists always play with art
materials and other materials surrounding them (Szekely 1983).
Undoubtedly, playfulness is an important ingredient in artists' creation
process because of its potential for supplying them with the freedom to
generate ideas and produce artwork. Playfulness allows artists to access
and be aware of the beauty of shapes, colors, lines, and some other forms
before putting them into the construction of art work (Szekely 1983).
One art student, for instance, claims that he creates three-dimensional
worlds through imaginary play (Franklin 1994). Like adults, children's
art and play are indistinguishable from each other (Hoorn, Nourot,
Scales, and Alward 1993). The role of art in play, and that of play in art,
seems to indicate that they strengthen each other in children's learning.
As Szekely (1983) stated, "The fewer the barriers between the play ses-
sions and the artwork, the more the one will assist the other" (20).

Because play and art are connected to each other through intersupportive functions, the shared features of both can help us to understand how both assist children to construct and represent their knowledge. These shared characteristics are derived from the analysis of the processes of children's play and engagement in art-making. They include the connection and interaction between internal and external worlds, intentions for expression, the invention and creation of a fantasy world, the generation of narratives, and the construction and representation of symbols.

Szekely (1983) claims that play is part of the creative processes. He describes play as "a way of research for both artist and child, allowing them to approach everything," and argues that it provides learning through experience (24). Play indeed provides both artists and children the freedom to create without taking risks. Consequently, Prentice (1994) recommends that teachers "initiate young children through play into art" (135). In other words, a playful classroom atmosphere is best for children's art-learning. Likewise, Kolbe (1993) claims that play is important for children's learning in art. One further connection between play and art is made by Matthews (1984), who believes that play is essential to the development of drawing. These perceptions tell us that playfulness is important in the process of art-making and learning in art (Szekely 1983). Children's art perceptions are expressed through play; for some children, art is their play (Wilson 1987). In other words, while engaging in art, the children are playing as well. It is frequently found that children's symbolic play is developed during the process of art-making. For instance, during my observation of children's art classes in a kindergarten, I found that a boy made two long strips of clay, piled one upon another, and pretended it was an airplane. He held the airplane high up above his head as if he were playing with an airplane flying in the air.

In addition, artificially implementing play into the art curriculum can arouse children's interest in art. Veale (1988) suggested a method of implementing play into the art curriculum by exposing children to talk about the design of toys. Conversely, children's art is integrated into play as well. That is, while engaging in play, they spontaneously bring art into the play context to meet needs of the play.

For instance, I observed my nephew, a seven-year-old boy, making a helmet and a sword out of cardboard in response to the needs of his pretend play as a knight. This kind of self-made toy makes children's play more joyful and creative (Mellou 1995). These examples reveal the con-

nection of art and play. They demonstrate how art assists the needs of play and how play supports children's learning in art and fosters their skills in art-making.

Shared Features of Play and Art: An Intertextual Relationship
Play and art share several characteristics in an intertextual relationship. Intertextuality refers to the process of making connections with past texts in order to construct understanding of new texts. Readers understand the new by searching past experiences with texts (including talk, play, and visual art) and life to find connections that will bring meaning to the current text. The greater range of experiences and texts that are combined, the more complex the understanding (Short 1992). This complex understanding is important in order to appreciate the world of children. Play and art make this intertextual reality for children come alive, especially when we consider the connection and interaction between *internal* and *external* worlds of the individual, the function of expression, the involvement of imagination and invention, the interweaving of narratives, and the use of symbols for meaning-construction, representation, and communication. Prentice (1994) reminds us that a creative person is one who can connect the objectivity from the outer world with the subjectivity of his or her inner world. For instance, the process of making an artwork involves the interaction of both the artist's feelings and ideas (inner world) and the expression he or she gives the outer world.

During the process of making art, an artist expresses his or her intention and at the same time yields that intention to the emerging products. In other words, the internal intentions vary as the work (external product) develops. Thus an artist plays two roles in the state of making art, that of creator and responder. Prentice (1994) called the reciprocal interaction between the artist and the work a conversational exchange.

The same connection of both inner and outer world is observable in children's play. As a child plays, interactions operate between ideas and materials. That is, when a child manipulates a toy, the properties of the toy also affect his or her play. For instance, a child may choose to play with a pencil as a gun (on the basis of the internal concept that relates a gun to a pencil), since they both share a similar shape. The shape of the pencil influences its preference over a ball as a symbol for a gun. Thus, in symbolic play, children internally inject meanings into objects in the external world.

Narration in Transmediation

Narration adds another facet to the process of transmediation. Typically, narration occurs concomitantly during the process of art-making and play. Narration is used by people to create a context and coherence (Forman 1996). Children's narrative is usually interwoven into their play and art activities. Paley (1995) indicates that children's play is frequently filled with characters and plots. Paley claims that "fantasy play and storytelling are never far apart" (8). Dramatic play is one of the examples of children's play with narrative. In dramatic play, for instance, children enact roles and actions based on the underlying storyline, and through their actions and dialogues they develop the plot (Hoorn, Nourot, Scales, and Alward 1993). Consequently, through dramatic play, children's stories are portrayed.

The same feature is shared by children's art. Children's words and pictures frequently cooperate to construct meaning (Eubanks 1997). Thus, language assists children's expression in art-making (Wright 1994). While engaging in drawing or other constructing activities, children are narrating stories (Wilson 1997). They draw stories showing characters, settings, dramatic relationships, what happens, what happens next, and how things finally turn out" (158). Dyson (1990) described the situation when children made drawings with the accompaniment of talk as "a canvas for children's shared dramas" (54).

Whenever the representation shown on the paper or their constructions cannot vividly or completely transfer their ideas, their verbal representation leaps out to lend a hand. The most salient example that shows how narrative assists children's drawing is the depiction of the unseen, like the image of sounds, smells, tastes, and so forth (Wilson and Wilson in press; Wright 1994). "For instance, when drawing a car running on the road, a child verbally produces the sounds of the engine and complements the drawing with descriptions of what is happening with the car; when making a bowl of soup with water and sand in their play, children would add some descriptions such as "so sour, so delicious."

Symbols for Meaning Construction, Representation, and Communication

Both play and art involve children in communication with others through meaning-construction and representation (Johnson 1990; Kolbe 1993). This is called symbolic representational behavior (Becher and Wolfgang, 1977). Children transform their thoughts, feelings or meanings through

symbol-construction to represent their intentions or meanings for com-
munication (Eisner 1990; Franklin 1994). In other words, they symboli-
cally explore their world through play and art. Thus, children are known
as both symbol-creators and symbol-users (Kolbe 1993).

Dyson (1990) also calls children symbol-makers and symbol-
weavers because these skills are inherent in competently expressing their
feelings and ideas through different types of symbols. Through meaning
creation and representation, ideas or experiences are expressed and rep-
resented in forms that make the meaning more graspable (Smith 1982).
Forman (1994) believes that the multiple ways of representation help
children to understand concepts more deeply.

Golomb (1974) claims that children's symbolic play and art involve
the use of representation that originates from their playful exploration
with the media and with symbolic transformation. The vehicles young
children use for symbolization to transform their meanings include ges-
tures, talking, storytelling, dreaming, play, drawing, singing, drama, and
dancing. These multiple modes of expression (or what other scholars
have called semiotic systems of communication) are demonstrated in play
and art. In play, a broomstick is used as a symbol to represent a horse; an
umbrella is transformed to represent a walking stick. These are examples
of transmediational representation children bring into play to communi-
cate with play partners. Likewise, art is a system of symbols children use
for communication (Eubanks 1997). Art activities such as drawing and
collaging are regarded as children's symbolic activities (Gardner 1980;
Stevenson and Duncum 1998). Children draw a circle (constructive
behavior) with radiating lines to represent the sun (representative func-
tion); they tear paper into a round shape and paste it onto another paper
and represent it as a human face. By doing so, the circle with radiating
lines and the round-shaped paper are rendered as symbols to embody the
child's concepts of the sun and a human face.

Conclusion: Toward a Framework of Implementing Play and Art in Classrooms

From the previous discussions, we understand that play and art are chil-
dren's tools for understanding the world around them. In this section, I
will give examples of teachers and their practices in classrooms to further
inform us about the strengths of play and art for children's learning and
how play and art interconnect to foster meaningful learning and proximal
development. There are significant benefits to be gained from integrating

play with school work and learning. Szekely (1983) emphasizes that play is essential to children's learning both before and during the process of art-making. He believes that when art instruction is introduced through play or planned around play experience, children will go beyond the teacher's guidance to create on their own. Once they are free from the constriction of the teacher's direction, they can more easily get ideas or find inspiration from their own personal experiences.

Furthermore, Payne (1993) points out that play can be helpful in children's early learning about art history. She recommends several activities for the art curriculum by implementing playthings such as building blocks, board games, shadow puppets, and so forth as aids for making learning interesting. In sum, when the imaginative element in children's symbolic play is added to art-learning, a flourishing development in art will happen. In other words, an imaginative context such as children's symbolic play is an essential element in children's art activities.

Symbolic Context in Art Classes: A Visit from van Gogh
Brent Wilson visited a second-grade class in Nebraska and found that the teacher had arranged a rich environment for learning about Vincent van Gogh. In this class, the students had set up an imaginary desk for van Gogh. When Wilson tried to sit at this desk, he was quickly stopped by the children. The following description of Wilson's experience will be helpful to understand how symbolic play was integrated in art learning and how it was beneficial for the children, especially as they made a connection with an artist in their lives:

> As the students began to re-draw their rooms, Brent Wilson looked for a place where he might sit and talk with some of the children as they worked. At the front of the room he spotted a vacant desk in a cluster of four. As he approached, one of the three children announced, "That's Vincent's desk." (Indeed, it was; his name-card was taped to the desk.) "Oh," he said, "May I sit in it?" "No! Vincent is sitting there!" One of the children exclaimed. Catching the spirit of the game, Wilson introduced himself to Vincent, pretended to shake his hand, and asked van Gogh how he had enjoyed his stay in the classroom. The children, their mouths agape, listened as van Gogh "told" his boredom in Arles, and Wilson explained to the artist how much he enjoyed his paintings and that he had visited the van Gogh museum in Amsterdam many times. The children were delighted, and the imaginary Vincent, also, seemed pleased with the conversation. The artist told Wilson that it would be OK if he wished to sit at van Gogh's desk. As Wilson sat down, one of the children explained that "van Gogh is indivisible." (Wilson and Wilson, in press, 3)

Art Classes in Japan

The Japanese national guidelines for art education, established in 1992, recommended that play activities be included in art classes. In the Japanese art textbooks for both first-graders and second-graders, play is incorporated into art activities. For instance, the first-graders can play with dirt to draw a picture with sticks or with water to make a painting on the playground; the second-graders make costumes out of newspapers, and so forth (Okazaki 1995). The main purpose of integrating play into art activities is to help children come up with creative thinking from a playful atmosphere.

Learning in an Italian Preschool: Reggio Emilia

In Reggio Emilia schools, visual language is highly focused and integrated into the program and becomes a central medium children use to visually and symbolically represent their thoughts, feelings, findings, and understandings of daily life (Staley 1998; Vecchi 1998). Every Reggio Emilia school has an atelier, a studio, where all kinds of materials are accessible to children for mastering techniques of symbolic languages (Schiller 1995). In addition, an atelierista, an art specialist, plays an important role in fostering children's knowledge-construction through art and thereby strengthening their skills in expression and representation (Gandini and Edwards 1988). These features distinguish Reggio Emilia schools from other preschools in Italy (Rabitti 1994). Children in Reggio Emilia schools construct, represent, and explore understandings through art, a process known as graphic languages (Katz 1998). The graphic languages include drawing, clay sculpture, wooden construction, wire sculpture, paper construction, and so forth (Schiller 1995). These types of art media constitute hundreds of children's languages (Staley 1998). The purpose of supplying the multiple languages to children is to help them understand concepts more thoroughly and to present ideas clearly to others (Forman 1993). Generally, children's representations of different ideas involve utilizing more than one mode of symbol system in a project. Forman called this process a demonstration of "cycles of symbolization" that fosters deeper learning and assists children to understand more complex concepts (176).

As illustrated in the three previous examples from Nebraska, Japan, and Italy, children's learning can be interesting and meaningful when there are no boundaries in the learning of different subjects and themes. Through art and play, different subjects become interconnected, and chil-

dren's learning is empowered. As explained by Eisner (1994), in each symbolic form or sign form, whether play or art, students do not transfer the same meaning, but create new ideas. Their play is full of lessons for themselves and for us adults who take care of them. Children use play and art as thinking tools. Taking heed of Eisner's wisdom, we are encouraged to know that to develop a whole child means to foster his or her development in cognition, language, social competency, emotion, and motor skills. As I have stated in this chapter, both play and art can reach the goal of facilitating the development of the whole child when adults understand the value of both and incorporate them into programs at school and at home to foster children's learning at every moment.

References

Balke, E. 1997. Play and the arts:The importance of the unimportant. *Childhood Education* 73, no. 6: 355–360.

Becher, R. M., and Wolfgang, C. H. 1977. An exploration of the relationship between symbolic representation in dramatic play and art and the cognitive and reading readiness levels of kindergarten children. *Psychology in the Schools* 14, no. 3: 377–381.

Berk, L. E. 1994. Vygotsky's theory: The importance of make-believe play. *Young Children* 50, no. 1: 30–39.

Burns, S. F. 1975. Children's art: A vehicle for learning. *Young Children* 30, no. 30: 193–204.

Clark, R. J. 1995. Violence, young children and the healing power of play. *Dimensions of Early Childhood* 23, no. 3: 28–30, 39.

Copple, C., I. E. Sigel, and R. Saunders 1984. *Educating the young thinkers: Classroom strategies for cognitive growth.* Hillsdale, NJ: Lawrence.

Dyson, A. H. 1990. Symbol makers, symbol weavers: How children link play, pictures, and print. *Young Children* 45, no. 2: 50–57.

Eisner, E. W. 1990. The role of art and play in children's cognitive development. In *Children's play and learning,* edited by E. Klugman and S. Smilansky. New York: Teachers College.

Eisner, E. W. 1994. *Cognition and curriculum reconsidered.* New York: Teachers College Press.

Eubanks, P. K. 1997. Art is a visual language. *Visual Arts Research* 23, no. 1: 31–35.

Forman, G. 1993. Multiple symbolization in the long jump project. In *The hundred languages of children: The Reggio Emilia approach to early*

childhood education, edited by C. P. Edwards, L. Gandini, and G. Forman. Norwood, NJ: Ablex.

Forman, G. 1994. Different media, different language. In *Reflections on the Reggio Emilia Approach,* edited by L. G. Katz and B. Cesarone. Urban, IL: ERIC Clearinghouse on Elementary and Early Childhood Education (Doc. No. DERR 9300 2007).

Forman, G. 1996. A child constructs an understanding of a water wheel in five media. *Childhood Education* 72, no. 5: 269–273.

Franklin, M. B. 1994. Art, play, and symbolization in childhood and beyond: Reconsidering connections. *Teachers College Record* 95, no. 4: 526–541.

Gandini, L., and Edwards, C. P. 1988. Early childhood integration of the visual arts. *Gifted International* 5, no. 2: 14–18.

Gardner, H. 1980. *Artful scribbles: The significance of children's drawings.* New York, NY: Basic Books.

Gardner, H. 1988. A cognitive view of the arts. In *Research readings for discipline-based art education: A journey beyond creating,* edited by S. M. Dobbs. Reston, VA: The National Art Education Association.

Garvey, C. 1990. *Play.* Cambridge, MA: Harvard University Press.

Golomb, C. 1974. *Young children's sculpture and drawing.* Cambridge, MA: Harvard University Press.

Hoorn, J. V., P. Nourot, B. Scales, and K. Alward. 1993. *Play at the center of the curriculum.* New York: Merrill.

Hughes, F. P. 1995. The use of play in therapy. In *Children, play, and development.* Needham Heights, MA: A Simon and Schuster Company.

Johnson, J. E. 1990. The role of play in cognitive development. In *Children's play and learning,* edited by E. Klugman and S. Smilansky. New York: Teachers College Press.

Johnson, J. E., J. F. Christie, and T. D. Yawkey. 1999. *Play and early childhood development.* New York: Longman.

Katz, L. 1998. What can we learn from Reggio Emilia? In *The hundred languages of children,* edited by C. Edwards, L. Gandini, and F. Forman. Greenwich, CT: Ablex.

Kellman, J. 1995. Harvey shows the way: Narrative in children's art. *Art Education* 48, no. 2: 18–22.

Kolbe, U. 1993. Co-player and co-artist: New roles for the adult in children's visual arts experiences. *Early Child Development and Care* 90: 73–82.

Landreth, G. L. 1993. Child-centered play therapy. *Elementary School Guidance and Counseling* 28, no. 1: 17–29.

Maitland, L. M. 1985. What children draw to please themselves? *The Inland Educator* 1: 77–81.

Matthews, J. 1984. Children drawing: Are young children really scribbling. *Early Child Development and Care* 18: 1–39.

Mellou, E. 1995. Review of the relationship between dramatic play and creativity in young children. *Early Child Development and Care* 112: 85 107.

Muri, S. A. 1996. "Mommy! Don't go bye-bye!" How art activities can ease separation anxiety. *Early Childhood News* 8, no. 1: 31 32.

Norton, E. B., and C. C. Norton. 1989. *Reaching children through therapy*. Greeley, CO: Family Psychological Consultants.

Okazaki, A. 1995. American contemporary art into Japanese school art: Play activities in the 1980s. In *Trends in art education from diverse cultures*, edited by H. Kauppinen and R. Diket. Reston, VA: The National Art Education Association.

Paley, V. G. 1995. Looking for Magpie: Another voice in the classroom. In *Narrative in teaching, learning, and research*, edited by H. McEwan and K. Egan. New York: Teachers College.

Payne, M. 1993. Games children play: Playthings as user-friendly aids for learning in art appreciation. *Early Child Development and Care* 89: 101–116.

Prentice, R. 1994. Experiential learning in play and art. In *The excellence of play*, edited by J. R. Moyles. Bristol, PA: Open University Press.

Rabitti, G. 1994. *An integrated art approach in a preschool. Reflections on the Reggio Emilia Approach*, edited by L. G. Katz and B. Cesarone. Urban, IL: ERIC Clearinghouse on Elementary and Early Childhood Education. (Doc. No. DERR 9300 2007).

Schiller, M. 1995. Reggio Emilia: A focus on emergent curriculum and art. *Art Education* 48, no. 3: 45–50.

Siegle, M. 1995. More than words: The generative power of transmediation in learning. *Canadian Journal of Education* 20: 455–475.

Smith, N. R. 1982. The visual arts in early childhood education: Development and creation of meaning. In *Handbook of research in early childhood education*, edited by B. Spodek. New York: The Free Press.

Staley, L. 1998. Beginning to implement the Reggio philosophy. *Young Children* 53, no. 5: 20–21.

Stevenson, J. N., and P. Duncum. 1998. Collage as a symbolic activity in early childhood. *Visual Arts Research* 24, no. 1: 38–47.

Szekely, G. 1983. Preliminary play in the art class. *Art Education* 36, no. 6: 18–24.

Veale, A. 1988. Art development and play. *Early Child Development and Care* 37: 109–117.

Vecchi, V. 1998. The role of the atelierista. In C. Edwards, L. Gandini, and F. Forman, (Eds.). *Introduction: Background and starting points. The hundred languages of children* (Chapter 7). Greenwich, CT: Ablex.

Vygotsky, L. S. 1973. The role of play in development. In *Mind in society,* edited by M. Cole, V. John-Steiner, S. Scribner, and E. Souberman. Cambridge, MA: Harvard University.

Wilson, B. 1976. Little Julian's impure drawings: Why children make art. *Studies in Art Education* 17, no. 2: 45–61.

Wilson, B. 1987. Why draw? Why drawing? The re-creation of the worlds of art. In *Teaching drawing from art,* edited by B. Wilson, A. Hurwitz, and M. Wilson. Worcester, MA: Davis Publications.

Wilson, B. 1997. Child art, multiple interpretations, and conflicts of interest. In *Child Development in Art,* edited by A. M. Kindler. Reston, VA: National Art Education Association.

Wilson, M., and Wilson, B. (In press). Why children draw? In *Teaching children to draw: A guide for teachers and parents.* Englewood Cliffs, NJ: Prentice-Hall.

Wright, S. 1994. Artistic development and learning: An integration of process for young children. In *The early years: Development, learning, and teaching,* edited by G. Boulton-Lewis and D. Catherwood. Victoria, Australia: The Australian Council for Education Research Ltd.

Chapter Five

Teaching Styles as Evidenced in Classrooms: A Semiotic Look at Picture Books

Deb Marciano

When I was a second-grade teacher, my students and I shared a wide variety of picture books on a daily basis. Our classroom was filled with these books for free-time reading, research, writing workshops, and take-home book bags. What is the connection between critical media literacy and picture books? Why should elementary teachers be concerned with helping young students develop a critical stance to what *they* read? How can this be incorporated into an already overpacked curriculum? Why is being media literate even important?

Doug Kellner (1995) says that the media are a profound and often misperceived source of cultural pedagogy: they contribute to educating us how to behave and what to feel, believe, fear, and desire (McLaren, Hammer, Sholle, and Reilly 1995, xiii). Picture books are often regarded as childlike and harmless. However, these are also a form of media, representing social, cultural, racial, gender, and class issues. They are not innocent; they represent popular culture. What happens when these representations are not accurate? How do these inaccuracies also create meaning?

Stuart Hall (1997) describes the shared meanings in any culture and the great diversity of meanings about any topic:

> It is participants in a culture who give meaning to people, objects, and events. . .
> In part, we give meanings by how we *represent* them—the words we use about
> them, the stories we tell about them, the images of them we produce, the emo-
> tions we associate with them, the ways we classify and conceptualize them, the
> values we place on them. Culture. . . is involved in all those practices. . . which
> need to be *meaningfully interpreted* by others. . . . Culture, in this sense, per-
> meates all of society. (3)

Picture books are an integral part of a children's introduction to literacy. Many of their first perceptions from other discourses come through the illustrations of picture books and the accompanying text that someone else might read to them.

If we are to help children develop a critical worldview, help them develop critical thinking, and make sense of the actions around them, then it seems that picture books might be a place to start. Many children have been exposed to picture books before they even reach school. Most are familiar with the interconnection of picture and text. Emergent readers cue into the illustrations long before they recognize the words on the page as they are being read to by others. They are forming their own opinions based on what they see; concepts that will stay in their minds for years to come. If picture books represent topics in predominantly one way, then, do they suggest that one way to be normal? Hall (1997) characterizes the production of meaning:

> Where is meaning produced? Meaning is constantly being produced and exchanged in every personal and social interaction in which we take part. . . Meanings also regulate and organize our conduct and practices—they help set the rules, norms, and conventions by which social life is ordered and governed. (3–4)

What meaning is being produced for young children? What and how are children reading? How does what and how they read affect their thinking for years to come? Is there room for multiple interpretations? Does a "first" reading render an indelible memory that in their young minds is "true," the way things must be, because that is how it has been represented in a book? Are patterns so reinforcing that their perceptions are ever fixed for time?

Again, the lens of the reader shapes the meaning one makes of media. The interactions of one's prior experiences, understandings, and attitudes create the meaning drawn from reading these picture books and their representations of school. What "schooling" means varies according to the transaction between reader and text. In picture books, as with any media, the intended audience is not always the only recipient of the representations of the creator's experiences, understandings, and attitudes. In essence, we, the readers, are attempting to make our own meanings via the meanings already made, in this case, by the author and/or illustrator of the picture books. These messages are often accepted without a critical glance.

Hall (1997) argues that images "help set the rules, norms, and conventions by which social life is ordered and governed" (in this case portrayals of schools, teachers, and schooling) (4). Are representations of schooling in picture books on the order of the culture of "school"?

Elementary teachers have a responsibility to help their students develop the abilities to read the world and the word. This critical pedagogy crosses boundaries of "the way things have been" to imagine possibilities, to not accept things as black and white, as fixed in time, or as the way the media represent them.

In this chapter, I explore examples of classroom settings in picture books that are generally geared for children ages five through eight. Each of the books I chose contain representations of school, teachers, and learning. An earlier analysis that I conducted of ninety picture books from the juvenile collection of a local public library yielded several patterns. Most of these books represented traditional classrooms with a white female teacher. This caused me to look more deeply at both text and illustrations. What meanings are children producing when they interact with the text of picture books?

Barone, Meyerson, and Mallette (1995) researched teacher attitudes toward students that are represented in picture books. Greenway (1993) similarly reports negative images portrayed in schools. She discusses school as a place to be avoided because it is repressive, deadening, and humiliating (1993, 105). Popular cultural representations are also presented in Joseph and Burnaford's book, *Images of Schoolteachers in Twentieth-Century America: Paragons, Polarities, Complexities* (1994). More attention is being drawn to the images and portrayals of teachers and schooling within popular culture. Where do these images arise? How do children, as well as the adults who read to them, form opinions of what school is like?

Figure 1 illustrates sources within society that influence and shape the perceptions of images of schooling. Think for a moment, if you will, of an elementary classroom from your own experience. Dig deeper into your memory. Tap your senses. How did it look, sound, smell, feel? What emotions does this image conjure up in you? How is this image representational of your view of the schema of "classroom"? Did it shape your future expectations of what school and classrooms would be?

Now what would happen if every representation you experienced in other picture books reinforced that image of school and each picture book presented a similar or exact duplicate of the previous book? Wouldn't you

develop a stronger conviction that your schema was how it must be? In the picture books I reviewed, traditional classrooms reign. Historically, Cuban's 1993 notion of the grammar of schooling is the way classrooms have always been. In many of our experiences as children, school looked a certain way, usually with straight rows of desks facing a blackboard (Cuban 1993). Classrooms have traditionally been teacher centered, while students sat, usually quietly, as empty vessels, receptacles for the knowledge transmitted by the teacher (see Freire 1985).

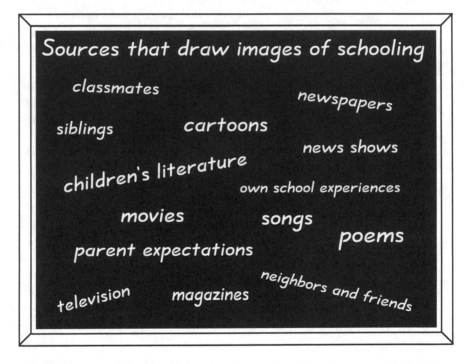

Figure 1: Popular cultural aspects that shape images of schooling

In the ninety picture books I reviewed, a scientific management methodology is most prominent. Prior to the 1970s, that image might have been the reality, but in the 1990s, classrooms have changed, yet these picture books (which have publication dates of 1978–1998) do not reflect these pedagogical changes. The illustrations in a picture-book, as well as the text, offer a unique view for the reader. In the books I reviewed, we catch a glimpse of how some classrooms look and perhaps

function within these stories. These classroom vignettes may or may not always be representational of the whole school, but that is not the central point of this study. What I do focus upon is the pedagogy of "doing" school. What are the cultural rules, norms, and conventions of which Hall (1997) speaks, represented through images of schools in children's literature?

I offer examples for your own examination of classroom settings and the implications of the pedagogy and ideology derived from such settings. While examining each picture-book illustration and text, keep in mind the following questions. What are the truths? The half-truths? How do we help young children look critically at what they see and critically read the text with which they interact? *Who* is represented and *how* are they represented? How can we, along with our students, examine, not representations of "doing school," but the imagery represented in both text and illustration in picture books?

In his popular *Arthur* series of picture books, Marc Brown repeatedly shows us Arthur's classroom. The books have led to a television series on PBS. The animated version makes Brown's classroom representations even more believable than the still illustrations of his picture books. In *Arthur's Teacher Trouble*, we meet Arthur's teacher, "The Rat," Mr. Ratburn. Students line up in alphabetical order to leave the classroom. Students are taking a one 100-word spelling test while through the window we glance at another class leaving the school for a field trip to the aquarium. Stress is evident on Arthur's face as well as those of his classmates. The chalkboard is filled with a minimum of twenty-one triple-digit addition problems slated for homework. Students look fearful as they wait for the teacher to correct their tests. Is this what classrooms of the 1990s are like?

Think about this classroom illustration. What does the teacher value? Mr. Gordon, the teacher in *James and the Dinosaurs* (Johnson 1995a), has students all facing his desk while working on the same page in their workbooks. Further assignments are written on the blackboard. The walls are covered with similar student drawings of dinosaurs.

Little Hippo Gets Glasses (Macdonald 1991), *My School, Your School* (Birnbaum 1990), *Miss Nelson Is Missing* (Allard 1977), *Never Ride Your Elephant to School* (Johnson 1995b), and *Outrageous, Bodacious, Boliver Boggs!* (Haprer 1996) are other examples of picture books that show traditional classroom settings and scientific management ideologies.

Mr. Johnson's classroom in *I Don't Want to Go Back to School* (Russon 1994) is filled with a variety of animals and posters. Individual

unholy alliance actually result in the revitalization of learning and the meaningful engagement of students with the curriculum? Besieged by more questions than ready answers, I closed my classroom door and proceeded with the daily drill.

More than any other group, ethnic minority children have been the unwitting victims of an educational system that exalts uniformity, conformity, and monolingual forms of discourse that have served not only to alienate and disempower them but also to silence their multiple voices—to discredit and de-legitimate the unique lived experiences they bring from their respective communities and from whose locations they engage the world. As both consumers and producers of popular culture—that is, as both being influenced by and influencing mass culture—urban youth need to be exposed to forms of emancipatory pedagogy that will allow them to "speak from their own experience at the same time that it encourages them to identify and unravel the codes of popular culture that may work to construct subject relations that serve to silence and disempower them" (Sholle and Denski 1995, 19). Since urban youth are wont to make substantial affective and material investments in popular culture, the task of critical media pedagogy must be to engage them at this site of contestation, supply them with a language to critique the oppressive structures that shape their yet partial and fluid identities, and help them to construct a counter-hegemonic response.

When I was a high school teacher, I was intrigued if not completely mystified by the appearance of what I then termed "street types" in my classrooms. Irrespective of where I taught, whether it was in urban or rural schools (both in Trinidad and the United States), this phenomenon would invariably appear among the largely minority-student populations (Black, Hispanic, or even East Indian students) with whom I worked over the years. I vividly recall one young woman who seemed to think that it was her constitutional right to utilize her sexual persona and aura to seek to influence my pedagogical judgment in her favor. Leslie (all names are pseudonyms) was an extremely bright, articulate, and competent student, who really did not need to practice her sexual politics in order to succeed in school either academically or socially, and I was completely baffled by her almost compulsive need to ensnare me with her well-endowed charms. There were also other "street types" who vigorously competed for my attention, such as Sean and Damian, who projected themselves as the official class comedians; Shiheed, the street-smart and street-tough "gangsta rapper"; Malik, the cool and lyrical dope peddler; Sean, who did

nothing but live for basketball; and Farryn, who seized every opportunity to entertain the class with her rap music and well-rehearsed dance routines.

As I became acquainted with critical theory and slowly began to appropriate its language, I came to view these "street types" as representing oppositional identities—attitudinal and behavioral positions that fail to conform to normative mainstream school culture. However, this did not explain how these oppositional identities were formed or how and why they were being reproduced in the classroom as almost faithful replicas of what I ambiguously defined as street culture. I believe that media literacy theory can provide classroom teachers with the necessary tools and language to analyze such classroom phenomena and can equip teachers as well as students with appropriate strategies to engage the multiplicity of often-contradictory messages generated by media and reflected in popular culture.

In order to better understand how school identities of African-American children in urban educational contexts are formed, we must examine the multiple popular cultural texts against which they "read" the world—the products/commodities that they consume as well as the specific manner in which these cultural products are appropriated and reproduced in the classroom as oppositional identities. According to Adorno and Horkheimer, "any account of cultural forms must include an examination of their processes of production, reproduction, distribution, exchange and consumption" (in Sholle 1995, 150).

In this chapter, I will attempt to examine not only those processes that account for the appearance of identities that conflict with a homogenous school identity but also seek to identify the multiple sites from which such identities are derived. Such an exploration of identity construction via media will offer urban teachers at all levels of the school system a better understanding of the social contexts from which students come and, in turn, help their students to understand the forces that shape students' identities and behaviors. Teachers will then be able to teach students to critically engage dominant ideologies that limit or restrict their possibilities and life chances and to ultimately empower them to become subjects rather than objects of their own lived realities.

Because the subject, that is, the individual student, is a product of his/her social milieu as well as specific historical circumstances, Michel Foucault's knowledge/power theory would prove a useful analytical tool with which to examine the construction of identity by urban Black stu-

dents as this process takes place against the backdrop of cultural and economic conditions of the wider society. Using Foucaultian theory, I will explore issues of ideology and power through the intersections of race, class, gender, and sexuality. I will attempt to deconstruct several of the more popular stereotypes of Blacks found in popular culture, illustrate how their respective subjectivities/identities have been produced in specific historical contexts, demythify their ideological constructs, and establish an unambiguous linkage between oppositional identities in the urban classroom context and their sources as exemplified in popular youth culture. Using the works of major critical media theorists (Hall 1997; Fiske 1989; Kellner, 1995; and others), I will also seek to analyze the processes of representation and commodification through an examination of specific cultural artifacts—video clips, pictures from rap/hip-hop magazines, pictures from sports magazines, and compact disc covers from rap/hip-hop artists.

Finally, I will propose a critical pedagogical framework for the analysis of cultural artifacts that are appropriated by urban minority students in the construction of their classroom identities as a counter-hegemonic response to media assault and colonization of this oppressed group.

Classroom Identities and Social Control

For many urban Black youth, hip-hop culture is perceived as representing the authenticity and realness of modern urban life. Part of that authenticity and realness involves aggressively establishing one's "rep" (reputation) within one's "crew." Many hip-hop fans, artists, musicians, and dancers continue to belong to an elaborate system of crews or posses. Tricia Rose (Ross and Rose 1994) defines a crew in the postmodern sense as "a local source of identity, group affiliation, and support system. [It] appears in virtually all rap lyrics, and cassette dedications, music video performances and media interviews with artists" (78).

Since identity in hip-hop is deeply rooted in the specific, the local experience, and one's attachment to and status in a local group or alternative family, the crew represents the new postmodern family in the postindustrial era, supplanting the much-maligned "dysfunctional" Black family and providing insulation and support in a complex and unyielding environment. Much of the perceived negative behavior of Black youth in urban classrooms stems not only from their acting out of the stereotypes with which they identify but also from a psychological need to establish their rep when challenged, often by aggressively confronting members of

other crews in verbal jousting or physical assaults. When I taught in urban middle schools and high schools, what I found most interesting about this aspect of student culture was that Black or Latina females, more so than their male counterparts, tended to engage in fighting as a means of protecting their reps.

Within the Anglo-European school culture, there are numerous rules in place to control what is regarded as "deviant" behavior by students. Males cannot wear hats in many schools; females cannot wear short, tight-fitting clothing. Carrying boom boxes within the school building or classroom, listening to any form of music while class is in session, "bombing" walls and other school spaces, wearing beepers, and carrying cell phones are all considered inappropriate behavior and often result in detentions, suspensions, or other forms of punishment.

Foucault's (1977) technologies of power theory sheds great light on the efforts of school administration personnel to crack down on "deviant" behavior. Administrators in urban educational environments spend a disproportionate amount of time addressing discipline issues and dress codes as they seek to control those identities from urban Black culture that threaten to undermine the system. For example, Black students' style of dressing has invoked many mandatory school dress codes (Irvine 1990, 28). Their dress has been characterized as conspicuous, colorful, visually stimulating, expressive, and intense. Kochman (1981) claimed that Black males and females, more than Whites, associate clothing with self-worth. Unfortunately, designer hats, sunglasses, jeans, athletic shoes, and gold jewelry are status symbols that Black teens use to express their self-worth in a world that consistently sends messages about their powerlessness and inferiority.

Interestingly, as majority-status teens adopt Black cultural dress styles, schools become more tolerant and less punitive (Irvine 1990, 28). Students' accessibility to technology (boom boxes, cell phones, and pagers) has also resulted in a proliferation of school sanctions as students attempt to reproduce the identities acquired from hip-hop culture. The contrasts between urban and suburban schools with respect to the control of students' symbolic creativity are indeed striking. While minority students in urban schools are often penalized for their use of cultural artifacts from popular culture, their White counterparts are often applauded and affirmed by school personnel. After the school shootings in Columbine, Colorado, it was fascinating to see many White students pulling out cell

The television comedy *Martin* is a classic example of Black male patriarchy at work. As the title of the show implies, all of the major events and scenes revolve around Martin, a struggling talk-show host at WZUP (What's up) radio station. The character of Martin is portrayed as a typical loud-mouthed, trash-talking, overly macho "bad-assed nigger" who gets out of entanglements based on his street smarts and coolness. In this "heroic" activity, he is ably assisted by his live-in girlfriend Gina (a light-skinned Black female) or his posse, Tommy and Cole, all of whom he "disses" (disrespects) with impunity. But he reserves the bulk of his sexist jokes for Pam, Gina's girlfriend, whom he usually describes in animalistic terms. Though both women in the show are well endowed, his nemesis Pam is portrayed as a whore; she is constantly dressed in tight-fitting skirts or pants to accentuate or fetishize her rear end and ample bustline.

Neither woman is portrayed as particularly intelligent (only Martin shines on this program). Tommy is portrayed as an out-of-work "brother" whose income derives from dubious means (possibly drugs), while Cole is cast into the role of "working idiot" because he gives all of his wages to Big Shirley, his grotesquely overweight older-woman girlfriend who remains invisible but whose presence is often alluded to. All of the women who "don't take no stuff" (i.e., refused to be trampled upon) are depicted as mean and ugly.

The Fresh Prince of Belair is another example of a Black sitcom that perpetuates Black stereotypes even as it pokes fun at Black middle-class aspirations. The story line is that Will, alias the "Fresh Prince," a savvy, cool, and street-smart adolescent from Philadelphia, is hustled off to live with his rich Black upper-class aunt and her family in Belair, California, to rescue him from the gang violence prevalent in the 1970s and early 1980s in his hometown. Will's cousins—Carlton, Hillary, and Ashley—are portrayed as pampered rich kids who have no understanding of the "real" world. Where Carlton is a nerd and a wimp, Will is street smart and macho. Where Ashley is young and innocent regarding relationships, Will is expertly knowledgeable. Hillary is cast as the "beauty with no brains" type; a typical character prevalent in both White and Black sitcoms (e.g., *Married With Children*). Will is, of course, able to emerge from most of his escapades relatively unscathed, due to his reliance upon his street smarts and coolness, while generally making a fool of everyone. Uncle Phil, though snobbish (he's a judge), is perhaps the only family member

who is able to see through Will's schemes and help him understand the pain and suffering he might have caused himself and others.

Both protagonists, Martin and Will, are the quintessence of Black masculinity and sexist behavior. They both objectify women and are emotionally insensitive and narcissistic. Their macho views and opinions carry the most weight in their many interactions with the supporting cast, while the views of their female cast members are never equally represented or validated. Both sitcoms deliberately favor one class over the other: in *Martin* it is the Black working class that is privileged while the middle class is ignored; in *Fresh Prince* it is the Black upper-middle class with all its wealth and pretensions that is the primary focus, to the exclusion of other class groups within the Black community. Maleness—being a "real man"—is restricted to Black machismo while other representations of maleness (e.g., being soft, sensitive, and caring) are omitted or are made to appear effeminate.

Teaching Students to Critique Popular Culture

While our students obviously derive great pleasure from their consumption of such commodities (cultural artifacts), how do we move them from being consumers-producers of this culture to a position of critical awareness whereby they will be able to decode and recode the multiple and contradictory messages embedded in the cultural texts they privilege? In this regard, employing a critical media literacy strategy can certainly prove useful in moving our students onto the stage of action as they endeavor to transform structures of domination that limit their possibilities of being and becoming. The critical-pedagogic media framework I use incorporates the cultural work of theorists of popular culture (see Hall 1997; Fiske 1989; and Willis, 1990) and other major theorists such as Gramsci (1971), Giroux (1983), and Foucault (1980).

At the first level of analysis, students should be taught how to conduct a *content analysis* of the particular artifact or cultural commodity that is being studied. Thus far, in this chapter, the cultural artifacts examined using this method were two Black sitcoms (*Martin* and *Fresh Prince of Belair*). We will also conduct a content analysis of a compact disc cover from a rap group called So So Def Bass All-Stars that will use several theoretical frameworks. A key concept that must be clearly defined for our students at this stage is that of *representation*. Critical theorist Stuart Hall (1997) offers the following definition:

Representation is the production of the meaning of the concepts in our minds through language. It is the link between concepts and language which enables us to refer to either the "real" world of objects, people or events, or indeed to imaginary worlds of fictional objects, people and events. (17)

Translated into teaching terms, this means that through the system of *representation*, we seek to discover how the language (i.e., aural, visual, or written codes) of the artifact becomes linked to the mental *representations* (images or concepts) that we carry around in our minds about people, objects, or events (real or imagined). If we extend this definition to include the various ways in which we organize, cluster, arrange, and classify concepts, thus establishing complex relationships between them (paraphrase of Hall 1997, 17), it becomes clear that our mental schemas produce the images and meanings that we construct from our encounters with people, objects, or events. Through the process of *representation*, qualities are affixed to certain ethnic groups (e.g., all Asians are business oriented) such that those qualities come to portray an inescapable norm or standard by which every group member is judged.

A close examination of the So So Def Bass compact disc cover, for example, reveals a number of stereotypes of Blacks that have been perpetuated through various forms of media production. In terms of the women, the stereotypes that stand out are the "whores" or "bitches," who are portrayed in tight-fitting pants, skirts, dresses, and tops—the more to fetishize their ample cleavages and well-rounded posteriors—and have elaborate and well-coiffeured hairstyles, fake nails, and lots of jewelry.

From the picture, it is obvious that they are falling all over the "brothers" and their fancy cars. The "brothers" are represented as out-of-work hustlers, drug dealers, pimps, and players (or playboys). They are dressed in clothes depicting the life of the 'hood—baseball caps turned either backward or forward, designer T-shirts hanging outside of baggy shorts that expose underwear, conspicuous gold jewelry, beepers, and cell phones. On the walls of the various housing-project buildings are splattered paintings of hip-hop artists in various poses of rebellion (i.e., bad-boy images). In the center of the two apartment complexes is an oversized image of the So So Def Bass All-Stars, at whom one woman in an upper apartment is blowing amorous kisses.

After conducting a thorough content analysis of the artifact, the next step is to *contextualize* the people, objects, and events into a *socio-historical context*. At this level of analysis, it might be useful to ask, What is the background to this picture? What are the particular types of discours-

es that have combined to produce this image? In the case of the So So Def Bass All-Stars, this image, which is used to promote a new CD by this rap group, is clearly deliberately constructed to convey the concept of "reality" on the streets or in the 'hood. Two important questions that we need to consider at this point are (1) What are the origins of this "reality"? and (2) Can it claim to speak to the experiences of all Black people?

Here is where a history lesson can be woven into the project. An obvious question to pose to the students would be: Where did hip-hop originate? Since many students might be unfamiliar with the history of hip-hop culture, this is a unique opportunity for the teacher to establish important connections to their own experiences through a discussion of hip-hop's origins in the South Bronx during the 1970s, detailing the devastation of once-thriving Black neighborhoods occasioned by public policies and capitalist abandonment and the social and economic consequences for the inhabitants of those neighborhoods.

Michel Foucault's theory of "the subject" as the product of various kinds of discourses in a society serves to explain the emergence of the "rapper," the "gangsta," and the "graffiti artist" in urban Black culture. The persona of the graffiti artist, for example, was produced by the decay and degradation of inner-city life, by advances in spray-paint technology, by the relative vulnerability of public and community buildings, and by the existence of sprawling urban transit systems that provided him/her with ready-made canvasses on which to launch his/her own forms of semiotic guerrilla incursions on mainstream culture. In the beginning scenes of the sitcom *Fresh Prince*, the protagonist, Will, is seen attempting to deface the wall of a neighborhood school building with aerosol spray and is caught by a vigilant police officer. Among inner-city rival gangs, graffiti functions to mark one's turf or to issue warnings of reprisals for fellow gang members who have been killed or for deals that have fallen through.

The gang warfare that erupted in America's inner cities during the mid to late 1970s caused many families to send their sons away (down south, for example) to preserve their lives. The background to the *Fresh Prince* story is based on this historical event. This fact also coincided with the return of thousands of Vietnam veterans to their inner-city homes and neighborhoods where the lurking evils of poverty, homelessness, joblessness, and lovelessness turned many to the dark worlds of drugs and crime. The glorification of the gangster lifestyle by rap and hip-hop artists owes much of its popularity to the early gangster films such as *Al Capone*,

Scarface, and *The Godfather*. The autonomy of the gangster, his ability to take care of his own, his toughness and street smarts, and the respect and fear he received from his own gang members as well as his enemies proved to be overwhelmingly powerful messages for thousands of inner-city youth, who too easily became targets of police victimization and brutality or random acts of street violence.

Having dealt with the origins of hip-hop, its popular characters, and its symbols, we next need to consider whether such a "reality" rightly represents the collective experiences of all Black people. In order to fully explore this question, we will need to connect the concept of stereotyping with that of naturalization. To the extent that the stereotype is used as a controlling image, it carries within itself the power to restrict or limit the multiple meanings and identities of its subjects to one essential meaning and identity. Such controlling images thus become naturalized, or essentialized—they become fixed, static, frozen in time, or are reduced to their core elements. Obviously, all Blacks are not gangsters, drug dealers, and whores; they are not all illiterate; and they do not all live in public housing. Students must be taught that—with the exception of slavery—there is no singular Black experience that can adequately define Black people. The fact that all of the Black experience is reduced to a few negative stereotypes is sufficient testimony to the power of the media to shape a homogenous identity for all Black people. However, the concept of identity becomes problematic for urban Black youth as they adopt the stereotypes as their true identities, not realizing that the stereotypes are, in fact, fictionalized entities that are fixed in U.S. culture and that severely limit their possibilities of becoming. Thus, they unwittingly play out the stereotypes in their experiences.

The third level of analysis deals with the decoding of messages embedded in the text. Who is the producer of these messages? How are they encoded in the text? What are the specific ideologies represented in these meanings? These are all questions that need to be answered if we are to gain a critical understanding of the text(s) we have chosen for analysis. Relying on the theoretical works of Michel Foucault (1980), Antonio Gramsci (1971), and Karl Marx and Engels (1974), we will endeavor to move into the zone of what Ann Pailliotet (Semali and Pailliotet 1999) calls "deep viewing." Marxist theory seeks to lay bare the inherent contradictions of capitalism—the class struggle that exists between the haves and the have-nots, the dominant and the dominated,

the bourgeoisie and the working class. These tensions are mitigated by *ideological domination*.

According to Marx and Engels, those groups who own the means of production thereby control the means of producing and circulating a society's ideas. Hall expands this idea to fit our technological age: "Through their ownership of publishing houses, newspapers and latterly the electronic media, the dominant classes subject the masses to ideologies which make the social relations of domination and oppression appear 'natural' and so mystify the 'real' conditions of existence" (Hall 1997, 347–348).

The media industry is the prime culprit in the dissemination of ideologies of domination, which are disguised and made to appear natural. On the So So Def Bass compact disc cover, for example, the message is clearly a sexual one. The "real" men are the ones with the fancy expensive cars, the designer clothing, the cell phones, and beepers. These are the ones over whom the women are practically drooling. The message about Black women is that they are gold-diggers (i.e., extremely materialistic) and that they are an easy catch for guys with money and nice cars. What is conveniently glossed over is the exploitation of Black women by Black men. By virtue of their material possessions, the men are the ones who exert power over the minds and bodies of the women. We must hasten to add that no form of domination or oppression is ever totalizing; power is a leaky vessel, and the oppressed are always engaged in subversive acts of resistance against various structures of oppression. For example, the women on the album cover of the So So Def Bass All-Stars, though seemingly spellbound and drooling over the material possessions of the "playas," exercise their own form of power over the men in this text. If the men fail to produce the goods (i.e., fail to meet their criteria), their status in the eyes of the women will be considerably reduced.

The fourth and final analysis involves bringing our students to what Freire (1970) calls "critical consciousness." Having taught them to decode the messages hidden in texts or cultural artifacts, we must now guide them to think critically by making connections to wider public discourses surrounding the text(s). For example, the ways in which these texts are shaped by other larger discourses such as the dominant culture's negative perceptions of Black male and female sexuality, the criminalization of young Black males; the supposed abuse of the welfare system by Blacks and subsequent conservative calls to end welfare; and the militarization and privatization of urban space that ensure that the "mean

streets" remain as the only viable source of recreational activity for Black youth.

Such a discussion is vital as we attempt to move our students away from the issue of how things came to be to an examination of their role(s) in either reproducing these dominant ideologies or challenging them in the name of personal emancipation. By so doing, we become true transformative intellectuals, furnishing our students with the intellectual tools they will need to make sense of the disparate and contradictory threads of their existence in an often hostile and oppressive world. Such is the nature of an emancipatory pedagogy that places personal liberation and social justice at the heart of the educational enterprise and genuinely seeks to connect students' lived experiences to every aspect of the curriculum.

Conclusion

I would be remiss in my responsibility to my readers if I did not state here that this article was the result of a challenge thrown out to my class by our media literacy professor to think about practical ways in which we could make our acquired analytical skills in media literacy more accessible to classroom teachers. In keeping my use of academic jargon to a minimum and connecting theory to the cultural and social practices of students, I trust that I have been successful in providing teachers with a useful and practical framework for conducting critical work with their students.

The focus on popular youth culture as a viable site for pedagogy should not be construed as yet another gimmick to entice or manipulate our students. Rather, it flows from a sincere commitment on the teacher's part to address issues of social justice and equity as an urgent educational priority. Far too many of our urban minority youth have mentally dropped out of school because they do not sense a connection between their lives and what they are expected to learn. By paying close attention to the areas in which urban youth are wont to make substantial physical and emotional investments and creatively finding ways of incorporating these texts into our lessons, we can begin the process of re-engagement and structure more pedagogically challenging environments for our deserving students.

References

Fiske, John. 1989. *Understanding popular culture*. London: Routledge.

Foucault, Michel. 1977. *Discipline and punish: The birth of the prison.* New York: Pantheon.

Foucault, Michel. 1980. *Power and knowledge: Selected interviews and other writings*, edited by Colin Gordon. New York: Pantheon.

Freire, Paulo. 1970. *Pedagogy of the oppressed.* New York: Continuum.

Giroux, Henry. 1983. *Theory and resistance in education.* New York: Bergin and Garvey Publishers.

Gramsci, Antonio. 1971. *Selections from prison notebooks*, edited by Quinten Hoare and Geoffrey Smith. New York: International Publishers.

Hall, Stuart. 1997. *Representation: Cultural representations and signifying practices.* London: Sage Publications.

Irvine, Jacqueline Jordan. 1990. *Black students and school policies, practices and prescriptions.* New York: Greenwood Press.

Kelley, Robin D. G. 1997. *Yo'mama's disfunktional!: Fighting the culture wars in urban America.* Boston: Beacon Press.

Kellner, Douglas. 1995. *Media culture: Cultural studies, identity and politics between the modern and the postmodern.* New York: Routledge.

Kochman, Thomas. 1981. *Black and white styles in conflict.* Chicago, IL: University of Chicago Press.

Marx, Karl, and Frederick Engels. 1974. *The German ideology*, edited by C. J. Arthur. London: Lawrence and Wishart.

Ross, Andrew, and Tricia Rose. 1994. *Microphone fiends: Youth music, youth culture.* New York: Routledge.

Semali, Ladislaus, and Ann Watts Pailliotet. 1999. *Intermediality.* Boulder, CO: Westview Press.

Sholle, David. 1995. Buy our news: The melding of news, entertainment and advertising in the totalized selling environment of the postmodern market. In *Rethinking media literacy: A critical pedagogy of representation*, edited by P. McLaren, R. Hammer, D. Sholle, and S. Reilly. New York: Peter Lang.

Sholle, David, and Stan Denski. 1995. Critical media literacy: Reading, remapping, rewriting. In *Rethinking media literacy: A critical pedagogy of representation*, edited by P. McLaren, R. Hammer, D. Sholle, and S. Reilly. New York: Peter Lang.

Willis, Paul. 1990. *Common culture: Symbolic work at play in the everyday cultures of the young.* Boulder, CO: Westview Press.

Chapter Seven

Can You Picture It?
Semiotic Representations of
Social Class in Photographs

William Garcia-Cardona

A picture is worth a thousand words. So it has been said many times before. Different from other forms of media, photographs are "mute artifact [that] cannot speak, but can only be interpreted, and interpretation is a notoriously tricky game" (Fulton 1988). Used under the proper conditions, photography can be a wonderful means to build upon our students' background knowledge on topics, concepts, and people with which they may be unfamiliar, especially in a social studies or literature classroom. Photographs are also appropriate starting points for teachers who wish to initiate critical media literacy discussions across the curriculum.

The diverse media representations that are made available to our young people—in video games, television, billboards, music videos, and on the Web, just to name a few—are instruments of popular culture that not only engage these minds but also influence their views of life and people. It is no surprise that once a major tragedy occurs involving our youth, such as the recent Columbine High School shooting and bombing spree in Colorado, the general public points an accusatory finger at these diverse and often disturbing media messages as one of the major culprits of society's current woes.

Here is some food for thought. Levine (1996) reports that a child from ages 2 through 11 will watch up to thirty hours of television per week, while teenagers from ages 12 to 14 will watch an estimated twenty-six hours. (Where do they find the time for homework!) Although it is true that television viewing does decrease as children get older, it only means that other media representations are taking up the slack, such as recorded music on CDs, video games, and the Internet. It's little wonder that children can become so desensitized to real-world situations when

they consume images and meanings every day in an unrational and non-critical way.

So when educators talk about "reading" the media as if it were a book, we are saying that we can read into the messages, both intended and unintended, prevalent in these representations of the world. All media representations are not "innocent" or "neutral" reflections of reality but are carefully crafted constructions (Barthes 1977) by the reporter or painter or photographer or songwriter; in other words, the artist who gives form to this product. Critical media literacy skills are needed to develop in our children the necessary cognitive, emotional, and ethical abilities to be able to interpret these media messages.

What one needs to acknowledge is that what becomes represented as reality-based media representations are preconceptions framed by the lens of the particular artist that reflect her/his own attitudes, interpretations, and conclusions about that slice of life. It is up to us as consumers of these images to reflect on and negotiate upon the many possible meanings based on our own lived experiences. While it may be true that pictures do indeed say more than a thousand words, we also must acknowledge that they aren't able to tell us the whole story in an objective manner.

Media representations are concepts having commercial implications, whether they are reached through a photo used on the cover of a romance novel, or a billboard, or the CD liner. Media representations also have particular social and political implications, whether they are through a printed text trying to convince us to vote Republican or to participate in the latest AIDS walk or to denounce the adversaries of our nation abroad. Even in this regard any form of the media will look toward a shared event or occasion and frame it from a different preferred perspective so that no two stories are "read" the same way. And finally, media representations are developed with the purpose of engaging its intended audience's attention in personally pleasurable ways. As Zettl (1998) points out quite eloquently, it is "not just content alone or form alone that shapes our media experience, but the *synthesis* of both."

I have argued that photography can be a very useful instrument for teachers to use to build on their students' background knowledge on unfamiliar cultures, especially in sessions aimed at promoting multiculturalism. I define multiculturalism here not as solely a superficial celebration of foods or holidays but a practice that examines the contributions and struggles of each contributing variable, including race, class, ethnicity,

gender, cultural traditions, and language, to give a more complete picture of the struggles of each group (see Figure 1).

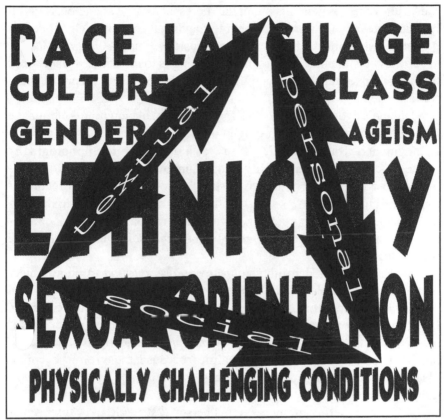

Figure 1: The inter-relation of variables within a critical media literacy approach

Through the (re)examination of a selection of six black-and-white photographs of Puerto Rican life taken during the 1940s and 1980s, I will offer a surface and underlying interpretation of these images depicting the people and events that shaped the lives of so many who lived in this time period. These photographs by Jack Delano, a highly regarded photographer noted for capturing the essence and emotions of the Puerto Rican people through his art, are good examples that can be used for illustrative purposes to accompany a discussion of Puerto Rican writers, such as Esmeralda Santiago and Judith Ortiz Cofer. They could also serve as companion pieces

for use in a social studies class that compares and contrasts the social, polit-
ical, and economical conditions of the island in the past and present.

Using a critical postmodernist lens, I will address questions regarding
the "truth value" statements about the representation of social class vivid-
ly depicted in this sample of photographs taken from Mr. Delano's
posthumously published book *Puerto Rico Mio: Four Decades of Change*
(1990). My task in this process of questioning is to introduce a framework
that will help to translate an activity such as this one from theory to class-
room usage.

Delano's work brings to the foreground two viewpoints about the
role of documentary photography in our lives. The first consists of what
Lemagny and Rouillè (1987, 12) saw as a dubious role of photography
in the process of creating reality as a documentary vehicle that depends
on whether the mind or the eye is struck by its capacities to record or
express. Hamilton (1995) sums up the second viewpoint in his reflec-
tion on the signifying practices of the mass media. He sees documen-
tary photography as both *objective representation* and as *subjective
representation*.

In the first case, Hamilton's *objective representation* in photography
is viewed as a simple record similar to an "official form, a letter, a will
with purely informational value" (81) or as "inherently objective." In the
latter case, very much like someone who records "selected material" for
his/her memoirs, the *subjective representation* is basically an interpretive
one with certain "truth value" qualities because the viewer becomes
placed within the event pictured but is still constrained by the choices of
the photographer.

Delano himself comments on this personal struggle over representa-
tion in his photos taken while working for the Farm Security
Administration (FSA) during the FDR years: "A photographer was some-
one who could take good, clear pictures of Pennsylvania Dutch antique
furniture and other objects of folk art. Although I considered this a per-
fectly respectable occupation, I was interested in photography of a differ-
ent sort" (20).

Although the intention of the FSA's Historical Section was to docu-
ment the agency's efforts to help post–Depression-era farmers and share-
croppers, it is no less true that a *dominant representational paradigm*
jumps out from the media representation. Images that are predominantly
displayed in the sample presented in the Delano book taken from the
impoverished rural countryside and the urban slums include those of fam-

Our fourth picture was taken in 1989 in a mathematics computer station in a San Juan private elementary school (163). (See Photo 4.) At the forefront, we can observe two girls working at their station observing their computer screens. At the back of the photo, six other children are pictured, four boys and two girls. All the children are dressed in their school uniforms. An adult, most probably the instructor, is seen working with one of the boys. Laminated signs with drawings of children are placed on the classroom walls. A bulletin board carries a sign indicating that this is the computer lab.

What does this image tell us about education and technology? What does this picture say about the state of private education versus the state of public schooling? Can we describe the children? What place does language have in the instruction? (The photographer has framed a computer screen with all-English instructions.) Does this indicate that one language has more prestige than another? What conclusions can be made about computer-assisted instruction from this photograph? These are only some questions that come to mind by observing critically this photograph.

Photo 4—1989: Mathematics class at a private elementary
school in San Juan
(Una clase de matemática en una escuela elemental
privida en San Juan)

*Photo 3—1946: Pledging allegiance to the flag, in a school in Corozal
(Saludo a la bandera norteamericana en una escuela en Corozal)*

thing to do with the usage of language, as indicated by the only words
prevalent in this photograph, which are all in Spanish? What does this
picture tell us about the importance of this ritual for the rest of the class?
What does the selection of this child say about the social class of the stu-
dents in this classroom?

Certainly a notion of the educational language policy of this time
period, which was a few years prior to its most important and enduring
change, needs to be addressed. It would be in the next two years that
English-language instruction would be relegated to one classroom period
per day, the Spanish language would be used as the primary vehicle of
instruction in all other classes, a policy that continues in most schools in
Puerto Rico to this day.

Photo 2—1981: In the home of the school superintendent of Corozal
(En la casa del superintendente de escuelas de Corozal)

all Puerto Rican middle-class families? And by identifying the type of work done by one member of this family, what does this say about social class, power relations, and community status? One final question—what other themes of family life are absent from the narrative and is thus denied to the reader?

Let us now look at how education is presented in Delano's documentation of the period. Photo #3, taken in 1946, shows us a young girl who is at the front of a classroom holding an American flag in her hands. The caption for this photo reads "Pledging allegiance to the flag in a school in Corozal." Although the girl is the central figure in this picture, other aspects are also evidenced, such as the type of construction used for this schoolroom, classroom content and drawings that appear on the chalkboards, and the absence of open spaces, since all windows seem to be closed (inferring from the lighting). It also tells us that this is an example of public education.

As one takes a closer look at this picture, a few additional questions arise. What is the intention behind documenting this daily act instead of showing the process of regular classroom instruction? Is this classroom symbolic of all classrooms in Puerto Rico in that time frame? Why was this classroom chosen from all the others in the school? Does it have any-

expressions. The caption indicates that this is an example of a Puerto Rican "family of a farm laborer in Barceloneta" (145), a town on the southwestern side of the island. But other pieces of evidence are not so neatly presented.

A few questions that come to mind include the following: Where is the father figure? Why is the family photographed from the waist up? Why was this family chosen? Is this family representative of all farmer laborers or of all destitute people of this period? Why does the photographer choose to frame this picture with the home's open door and loose clothing in the background? Can we safely assume that all the children pictured are members of this family? What does this picture tell you about Puerto Rican families living in the 1940s? As you can see, these questions touch upon only a few issues regarding representation, but they are important in our analysis of what a Puerto Rican family looks like. In an attempt to better understand the life experiences of the characters depicted in the works of Santiago and Cofer I mentioned ealier, it is important to examine critically the conditions of life characteristic of the time. Then we would ask ourselves as educators if this is an image that fits into the conceptual framework as symbolic of Puerto Rican family life.

On the other hand, let us look at Photo 2 taken in 1981. The caption tells us that we are observing the interior of the "home of the school superintendent of Corozal" (155), a town on the north-central area of Puerto Rico. Let us look at the obvious features documented in the photo. This is a photograph of the dining-room table, taken from a wide angle in which we can also observe part of the kitchen. Three people are photographed placed at the center of the shot and are dressed casually. We assume that they are the school superintendent, his wife, and a teenage son. The house is constructed not from wood but from cement, with shiny tiles patterning the floor and walls. Except for the round chandelier hanging over the round dining table, the rug under the dining table and chairs, and a photograph hanging from the wall, there aren't many other artifacts present in the photo.

These things are evident at first sight, but other questions come to mind about this representation of family life, similar to the ones mentioned earlier. Why was this family chosen? Are these people the extent of this immediate family, or are other members absent from the scene? Why was the photograph taken from the dining table and not, say, in the living room? What does the inclusion of the superintendent's son say about Puerto Rican youth? Can this family portrayal be representative of

ily life, children, farm labor, education, religious ceremonies, cultural celebrations, and living quarters. For the purpose of this paper, I will be focussing on three of these themes, namely family life, education, and cultural traditions.

These photographs could be interpreted as a vehicle to convey to the audience a story of an evolution, a progress, and a change that has marked this archipelago territory of the United States. By looking at the photographs we begin to understand part of this metamorphosis; the signs that mark one period of time from the other—agrarian versus industrial; poverty versus wealth; tradition versus imposition; innocence versus sophistication. Of the many possible variables that could be used to study these media representations, I have chosen to focus on social class for the purpose of this chapter (see Figure 2). With this approach, many questions come to mind that go beyond what is being portrayed. Let us begin with a look at two photos that portray family life in Puerto Rico during the 1940s and the 1980s.

In photo 1, this family's economic and social status are indicated by the type of dwelling, number of offspring, clothing worn, and facial

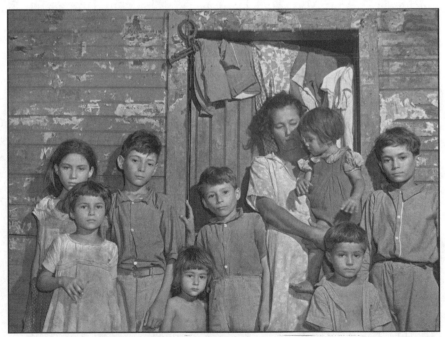

Photo 1—1941: Family of a farm laborer in Barceloneta
(Familia de un trabajador agrícola en Barceloneta)

Scene: _____

Variable: ○ Race ○ Gender ○ Class ○ Ethnicity ○ Other: _____

PHASE	TASK	LEVEL	STUDENT ACTIVITIES
1	"Reading" the "text"	Surface/ Decoding	Make lists, diagrams, charts of what appears in picture.
2	"Writing" the "text"	Surface/ Encoding	Write statements on the content. Identify as many components and character traits in narrative as possible.
3	"(Re)visiting" the "text"	Deep structure/ Critical	Make questions about missing pieces/voices and unanswered, unknown data.
4	"Interpreting" the "text"	Deep structure/ Analysis	Write judgment statements based on content. Observe possible stereotypical and hurtful depictions.
5	"(Re)writing" the "text"	Deep structure/ Reconstruction	Introduce missing voices and other perspectives that can change the text. Discuss how these changes help to balance hurtful portrayals.
6	"Writing" the "text"	Surface/ Decoding	Make lists, diagrams, charts of what appears in picture.

Figure 2: Framework for critical media literacy in the classroom

Our final examples deal with cultural traditions. The events are based on a 1941 Christmas party in the southwestern town of Guánica and a 1981 town celebration of the yearly Patron Saint's Festival, this one in the northeastern town of Loíza. Photo 5 shows us four people, all male, identified in the caption as "country musicians." Two of the musicians are children, accompanied by two adults who are playing guitar-like instruments. One child is playing the maracas. Signs indicating the social status of these musical guests are indicated in their clothing, hairstyles, and immediate surroundings.

Other information relevant to the content of this piece is unavailable and would be necessary to understand the rationale behind this traditional activity. For instance, are we observing a form of Christmas caroling? Why are only males portrayed in this scene and not other members of the audience? How would the story that is told be changed if we were able to insert these missing voices from the text? How would the intended interpretation for the photograph vary by assuming the perspective of one of its characters, like the missing heads of the household or the partially

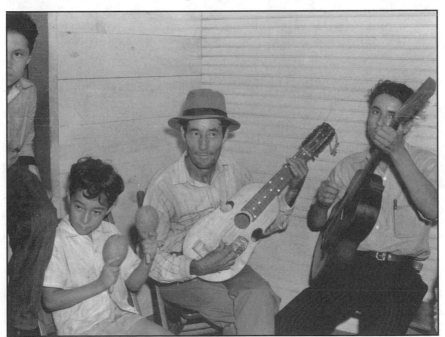

Photo 5—1941: Country musicians at a Christmas party in Guánica
(Músicos campesinos en una fiesta de Navidad en Gúanica)

viewable child on the left? Would we have been able to tell that this was a Christmas celebration without the caption?

Patron saint's festivals are held throughout each Puerto Rican town as social get-togethers and entertainment in two-week intervals throughout the year. All kinds of live music and good food are available in these celebrations. Knowing this piece of information is helpful in constructing the meanings within Photo 5. But still other notions are not so easily interpreted from the positioning of the people in this photograph. Questions about different shades of color of these Puerto Rican people are distinguishable here, and so are certain markers for male/female relationships and clothing. The choice of the photo site is called la esquina caliente (literally "the hot corner"); so what does this say about the people pictured here? Why would Delano decide to shoot his scene at a corner bar instead of the town plaza or one of the many food stands? It is also evident that most of the people photographed here were not posing for the photographer. They had no notion that this shot would serve as a permanent documentation of their acts for posterity. I would have to question if this is an ethical choice.

Once we are able to identify those media images that are harmful, that can be interpreted from a distorted and biased notion of reality, we must take the steps necessary to mend these images in our worldview as we look at new, more just interpretations of these representations. Developing "I believe" papers (Pailliotet 1999) or "compare/contrast" posters are two devices teachers can use to engage students to become empowered as they voice alternative ways of viewing these media images and to describe their personal journey toward a new consciousness of the new knowledge acquired in the process.

The role of the teacher is to help students to develop skills that will allow them to negotiate diverse meanings with each reading of the "texts"—readings that discern between the vast (and not singular) range of meanings, the values and paradigms implicit in those meanings, and the questioning of the purposes and sources. Children who achieve critical media literacy are empowered individuals who will make better life decisions. It is a way of integrating missing pieces to paint a more complete picture of those indiscriminate areas within a broader curriculum. In a democratic classroom, critical media literacy is synonymous with our goal of developing critical autonomy in our future citizens. Above all, critical media literacy helps us to make sense of these representations that

"tell us about who we are, what we believe, and what we want to be" (Tyner and Kolkin 1991).

References

Barthes, R. 1977. *Image-Music-Text*. Glasgow: Fontana.

Delano, J. 1990. *Puerto Rico mio: Four decades of change*. Washington, DC: Smithsonian Institution Press.

Fulton, M. 1988. *Eyes of time: Photojournalism in America.* Boston: Little, Brown, and Co.

Hamilton, P. 1995. *Robert Doisneau: A photographer's life*. New York: Abbeville Press.

Lemagny, J. C., and A. Rouillè. 1987. *A history of photography: Social and cultural perspectives.* Cambridge: Cambridge University Press.

Lester, P. M. (Ed.). 1996. *Images that injure: Pictorial stereotypes in the media*. Westport, CT: Praeger.

Levine, M. 1996. *Viewing violence. How media violence affects your child's and adolescent development*. New York: Doubleday.

Pailliotet, A. 1999. Deep viewing: Intermediality in preservice teacher education. In L. Semali and A. Pailliotet (ed.), *Intermediality: The teacher's handbook of critical media literacy*. Boulder, CO: Westview.

Tyner, K. R., and D. L. Kolkin. 1991. *Media and you: An elementary literacy curriculum*. Englewood Cliffs, NJ: Educational Technology Publications.

Zettl, H. 1998. Contextual media aesthetics as the basis for media literacy. *Journal of Communication* 48, no. 1: 81–95.

Chapter Eight

Semiotic Representations of Puerto Ricans in Hollywood Cinema: I Don't Like It Like That

René Antrop-Gonzalez

> There is no element whatever of man's consciousness that has not something corresponding to it in the word; and the reason is obvious. It is that the word or sign that man uses *is* the man [*sic*] himself. For, as the fact that every thought is a sign, taken in conjunction with the fact that life is a train of thought, proves that man is a sign; so, that every thought is an external sign, proves that man is an *external* sign. That is to say, the man and the external sign are identical, in the same sense in which the words *homo* and man are identical. Thus my language is the sum total of myself; for the man is the thought. (Vygotsky in Innis, ?)

Renting a video from a local establishment or going to a cinema are perhaps two of America's favorite pastimes. As the smell of buttery popcorn permeates the air, moviegoers are confronted with thousands of images. When the movie ends, one may innocently comment on the roles of main characters or discuss favorite scenes. After a short time, they will eventually go back to *reality* and continue living life on a day-to-day basis. However, one essential question comes to mind. How many of those movie fans have actually analyzed or viewed what they have just seen from a critical stance? In other words, have the movie's images been taken at face value or have they been examined for such things as negative and/or positive stereotypes, racist comments, or other images that may do nothing more than perpetuate class divisions between those groups that are traditionally considered to be dominant and those regarded as being minorities?

The answers to these questions are important to me because of the value I place on my Puerto Rican ethnicity. On many occasions, my mother and I were the unnecessary victims of racially biased comments

with regard to our Puerto Rican identity. Now, as a father of two daugh-
ters, I feel that I have the important responsibility of exposing my chil-
dren to those issues pertaining to race, class, and gender and teaching
them how these are decontextualized and abused by the mainstream,
white North American media industry in the name of entertainment. Who
gave Hollywood the right to trivialize and/or legitimize this lack of
respect for Latina/os and/or Puerto Ricans for the sake of a few laughs?
Most, if not all, Latina/os would argue that being ridiculed or made the
object of cocktail party jokes is no laughing matter.

The purpose of this chapter is to examine how Latina/os and, more
specifically, Puerto Ricans are portrayed in the U.S. media. This will be
done using a critical media literacy/postmodern approach. This approach
provides a systematic deconstruction of the negative stereotypes that are
conveyed throughout this particular culture industry. Some of the ques-
tions to be raised in this analysis include: Who produces such movies?
How does the hegemony engendered in the dominant group (and the way
it interjects its sense of superiority and limited worldview) influence the
(mis)representations of Latino/as and Puerto Ricans in U.S.A. cinema?
How might such (mis)representations serve to perpetuate notions such as
racism and stereotypes of Latino/as among students and in the larger pop-
ulation? Only by arriving at plausible answers to these questions can one
begin to decenter the negative images that Latino/as and Puerto Ricans
hold in the eyes of the White mainstream North American population. As
stated by Pérez:

> Media exclusion, dehumanization, and discrimination are part of the cultural
> domination inherent in unequal power relations, and a key feature of the histor-
> ical process by which people of color have been and continue to be subordinat-
> ed. Cultural domination involves racist omissions, stereotypes, lies, and
> fantasies that distort people. Recycled in various forms, these repeated distor-
> tions become part of the society's system, forming the dominant myths, sym-
> bols, vocabulary, and beliefs, which define the consciousness of a nation. (1998,
> 142)

Underrepresentations and (Mis)Representations of Latino/as in the Media

Hispanics, according to the U.S.A. Census Bureau, represent one in ten
Americans and are classified as those individuals of Latin American or
Spanish origin (Barone 1998). The term "Hispanic" or "Latino" general-

ly refers to those of "Mexican, Cuban, Puerto Rican, Dominican, Colombian, Salvadoran, and other extractions" (Massey, Zambrana, and Bell 1995). The media either underrepresents or (mis)represents Hispanics, thus helping to contribute to the erroneous or discriminatory perceptions that North Americans hold of them (Ferriss 1994; Sheehan 1995; Associated Press 1996; Superville 1996; Romano 1997; National Council of La Raza 1998; Ramírez-Berg 1998; Rodríguez 1998). Susan Ferriss highlights these perceptions in the findings of a study undertaken by the Center for Media and Public Affairs. The comments and statistics provided in the media are a cause of concern to any Hispanic or interested citizen who knows that minority groups in the United States are often discriminated against. She states: "Latino characters on prime-time television are four times more likely to be portrayed as gangsters, drug dealers and other criminals than [any] other ethnic groups" (1994, E5). Other findings from the same study reveal a curious picture:

- About 16 percent of the Latino characters during the 1992 season committed crimes, compared with 4 percent each by African-American and White characters.
- About 28 percent of the Latino characters were poor, compared with 24 percent of African-Americans and 18 percent of Whites.
- Only one Latino character was depicted as a business manager or executive, even though the number of Latino/as in business has grown significantly.
- On "reality-based" shows such as *Cops* and *America's Most Wanted*, the presence of Latino/as increased to about 8 percent. Out of that total, 45 percent were criminals or suspected criminals.

A study reported by Associated Press (1996) recapitulates similar derogatory perceptions about Latino/as:

- Latino characters committing crimes on TV declined from 16 percent in 1992–1993 to 6 percent in 1994–1995. But that was still higher than the percentage of White or Black characters who broke the law.
- Although Hispanics comprise 11 percent of the U.S. population, at 27 million, they represented only 2 percent of all prime-time characters in the 1994–1995 season.

- Of the 139 network and syndicated programs reviewed, 55 per-
 cent of the Latino characters were poor or lower-status working-
 class people. (A2)

What do these findings and statistics mean? Using a
Marxist/Gramscian framework, Ramírez-Berg (1998) explains how hege-
monic forces reinforce and perpetuate the negative images of Hispanics
in the media.

> Stereotyping in films slips effortlessly into the existing hegemony, the subtle,
> naturalizing way the ruling class maintains its dominance over subordinate
> groups. Viewed as a tool of the dominant ideology, the creation and perpetua-
> tion of stereotypes in the movies and in the media function to maintain the sta-
> tus quo by representing dominant groups as "naturally" empowered and
> marginal groups as disenfranchised. In the case of Hispanics, their portrayals as
> bandits and buffoons, whores and exotic clowns, Latin lovers and Dark Ladies,
> mark them as symbols of ethnic exclusion. (111)

Ramirez-Berg demonstrates that Hispanics are indeed portrayed neg-
atively in the media. From this point forward, I will illustrate how one
particular Latina/o group, the Puerto Ricans, is portrayed in the cinema.

(Mis)Representations of Puerto Ricans in U.S. Cinema

Several scholars (Jiménez 1998; Pérez 1998) discuss how Puerto Ricans
have been historically (mis)represented in films produced in the United
States. These racist depictions are the result of the colonial relationship
between Puerto Rico and the United States since the invasion of Puerto
Rico on July 25, 1898. The classic binary opposition of superior versus
inferior is seen as the impetus behind these negative film images. Pérez
suggests that "negative images of Puerto Ricans represent written and
visual expressions of White superiority and Puerto Rican inferiority. They
are historically constituted. These stereotypes existed even before the
mass migration of Puerto Ricans to the U.S. They developed as justifica-
tions for the American seizure of the Island and for continued coloniza-
tion" (1998, 145). Pérez quotes Senator Vardaman of Mississippi, who
declared his opinion concerning the possibility of granting United States
citizenship to Puerto Ricans during a congressional debate in 1916:

> So far as I am personally concerned, I really think it [is] a misfortune for the
> United States to take that class of people into the body politic. They will never,
> in a thousand years, understand the genius of our Government or share our

ideals of government. . . . I really had rather they would not become citizens of the United States. I think we have enough of that element in the body politic already to menace the nation with mongrelization. (quoted in Pérez 1998, 145–146)

It is obvious that Mr. Vardaman's racist declaration had no influence over his congressional colleagues as the Jones Act, the legislation that granted United States citizenship to Puerto Ricans, was passed in 1917.

Puerto Ricans continued to be the targets of racist stereotypes in the United States as "scholarly" studies and books published in the late 1940s and 1950s found them to be either oversexed, lazy, uneducated, physically unfit, or dysfunctional. To top this off, more than a dozen films portraying Puerto Ricans as juvenile delinquents were produced just between 1949 and 1980. Some of these include *City Across the River* (1949), *Blackboard Jungle* (1955), *Rock, Rock, Rock* (1956), *The Young Savages* (1961), and the well-known film *West Side Story* (1961) (Pérez 1998). In order to give the classroom teacher an idea of how media, such as film, can be approached from a critical media literacy approach, I have included my own analysis of a film that depicts Puerto Rican life in New York City.

A Critical Media Analysis of *I Like It Like That*

I Like It Like That was a drama/comedy released by Columbia Pictures in 1994. It was directed, written, and produced by Darnen Martin and co-produced by Diane Phillips. The film's running length is 108 minutes. The main actors and their respective characters are Jon Seda (Chino), Lauren Vélez (Lissette), Jesse Bonego (Alexis), and Lisa Vidal (Magdalena). All of the characters portray Puerto Ricans who live in a ghetto-type setting.

The plot is quite simple. It concerns the frequent fights in the marriage of Chino and his wife, Lissettte. They fight because Chino accepted employment with a music production firm in order to make money to support his family. The events leading to and taking place after accepting this newly found employment and the (mis)representations involving Puerto Ricans are what I wish to deconstruct. A search for reviews of the film showing how it was interpreted by the white mainstream media yielded only one review written by Jim Byerley of HBO. He found one particular aspect of the film disturbing. According to Byerley (1994), although Lissette and Chino have been married ten

years and have three children, just because they are parents doesn't mean they're adults. They yell, they push, they shove, they smack the kids, they yell some more. With a review like this, it is no wonder that Puerto Ricans are viewed negatively by the rest of white American society. In the next section I look closely at the stereotypes that such a review might project to viewers.

Stereotype One:
All Puerto Ricans are poor, live in ghettos, and are crooks
The first stereotype and major (mis)representation that is to be exposed is the particular setting of the movie. The film takes place in the Bronx, and all the characters are portrayed as being of a low socioeconomic class. In fact, the opening scenes of the film reveal Puerto Rican residents of the community playing the "numbers" game. This game is a type of lottery that is illegal. It involves a "runner," or someone who is in charge of collecting an individual's preselected numbers. Usually, a dollar is paid for each combination. After the pool of numbers and the money are collected, a drawing is held and the person who is lucky enough to have the winning combination of numbers is given a portion of the money that was collected. Of course, the person who operates the illegal lottery retains a large portion of the proceeds. In other words, the very first scene involves a negative portrayal of Puerto Ricans as criminals in this illegal activity. This image may very well lead the viewer to believe that all Puerto Ricans take part in these types of illegal activities that would make them criminals. This scene is offensive and questions the integrity of Puerto Ricans.

Other scenes throughout the movie that question the integrity of Puerto Ricans involve those scenes that depict a looting spree in which Puerto Ricans are shown to be inciting a riot and breaking store windows and stealing merchandise. Of course, Chino feels the pressure to please his wife and get her the stereo that he has wanted to give her for the longest time. As a result, he is unable to control his urge to steal and ends up being arrested by the police and placed in jail.

Lastly, Lissette, Chino's wife, is obligated to accept welfare benefits since her husband, after going to jail, is no longer able to provide for the family. At face value, these scenes portray Puerto Ricans in a bad light. Such behavior is certainly not the "normal" way that a Puerto Rican lives or acts.

Stereotype Two:
All Puerto Rican men are oversexed and machista
Another stereotype found in *I Like It Like That* reinforces Ramírez-Berg's (1998) notion of the "Latin lover" or oversexed *machista*. This stereotype is often found in films portraying Latina/os. In one of the first scenes, Chino and Lissette are engaged in sexual relations in their bedroom as their young children are left unattended. Pounding on the locked bedroom door and demanding to know what is going on, the children threaten to break the door down. This scene advances the notion that many Puerto Rican families are dysfunctional or irresponsible.

The movie also shows Chino holding a clock as he times just how long he is able to last before reaching ejaculation. As he breaks his previous record, he makes comments that reveal his joy and excitement at being the "perfect macho/Latin lover." Chino is also portrayed as being *machista* as he constantly protests Lissette's dream of working as a model. He makes it clear that he does not approve for two reasons: (1) He does not want other men staring at her, and (2) her place as a Puerto Rican woman is in the home taking care of the kids. After all, he is the man of the house and it is his duty to "bring home the bacon." Another scene that would help to reinforce the notion that all Latino/as and Puerto Ricans are oversexed involves one of the characters, Magdalena, and her never-ending quest to seduce Chino. She is very well aware that he is a married man, but this fact does nothing to deter her in her quest.

Do All Puerto Rican Women Dress and Act Like Sluts?
After watching *I Like It Like That*, one might ask whether it is true that all Puerto Rican women dress and act like sluts. This movie is especially offensive to Puerto Rican women; there are numerous scenes in which the women are dressed provocatively (they wear miniskirts, low-cut blouses that reveal a considerable amount of cleavage, high heels, and dark red lipstick). This film also depicts Puerto Rican women as being nothing more than sexual objects as they are chased and made the recipients of lewd comments by their Puerto Rican male counterparts. Even more offensive to the integrity of women is the scene in which Lissette (Chino's wife) has sex with her boss on the floor of his office as he is busy talking to a client on the phone.

Negative images such as the ones described in this section and in previous sections need to be analyzed, deconstructed, and questioned. Movies such as these do a great job of helping to maintain and perpetu-

ate the negative stereotypes of Puerto Ricans and threaten to challenge their place within American society. Perhaps the saddest aspect of these types of cinema productions is the fact that white writers and producers utilize Latino/a actors and actresses to perpetuate these stereotypical and negative roles. This is hegemony at its very best; these Latino/as are made pawns of the very same system that means to degrade them.

What Can Teachers Do to Combat These Types of Negative Stereotypes?

As teachers, we have a very important responsibility—to expose our students to such notions as race, class, and gender and how the mass media can (mis)represent them. Public school teachers need to be conscious of the fact that our student population is constituted of individuals from many different walks of life. Facts from the Center on Education Policy (1998) affirm the following:

- In 1997, 35 percent of children under the age of 18 were from minority groups. By 2020, this proportion is expected to increase to 45 percent.
- Today, 20 percent of the children in school are immigrants. In contrast to earlier waves of immigration, most new arrivals to our nation come from Asia and Latin America; only 12 percent come from European nations.
- The U.S. is becoming more religiously diverse; Islam is the fastest growing religion in the nation.

The media is a very powerful tool that can shape the way our students view those groups that are considered to be marginalized in our society. As the Center for Education Policy (1998) notes, "In diverse public schools, students can learn about other races, ethnic groups, and cultures through normal interactions, observations, and friendships, rather than through stereotypes and prejudices, or through television, movies, and books" (3).

According to Len Masterman, "A basic tenet of media literacy is that 'all media are symbolic sign systems that re-present (not reflect) reality'"(2) (as cited in *http://interact.uoregon.edu/medialit*). It is important that classroom teachers raise specific questions and implement practical activities in the classroom. This will better enable students of all instructional levels to realize that media (mis)representations are human con-

structions and are therefore subject to the deconstruction of those images that may only serve to expose such issues as race, class, and gender in a manner that may either favor or disfavor particular groups of people depending on who manufactures the images. What types of questions and/or activities can be used in the classroom that would foster critical media literacy?

Quesada and Summers (1998) and Rodriguez (1998) raise the following questions to help students analyze media (mis)representations critically:

- Who is telling the story?
- Whose point of view is being expressed?
- Is the author or producer a noted expert in the field? Has he/she researched or ever interacted with the subjects or topic with which he/she is writing or producing a film about? What makes him/her an authority with the topic that is being discussed? Is the information fact or opinion—or a mixture of both?
- Is there a built-in bias due to a political, economic, or social agenda?
- Who is the intended audience?
- Are the vocabulary, tone, illustrations, and other media elements appropriate for the intended audience?
- What is not being told and why?
- In the case of film, can the students imagine the world of the film as seen by characters who are denied a point of view in the film? Can an alternative scenario be developed by your students around the point or points of view of characters who function as peripheral, almost invisible, reactors to the central characters (for example, butlers, maids, waitresses, bartenders, cab drivers, and other victims)?
- How many of the film's themes address marginalized ethnic groups such as Africa-Americans, Latino/as, females, or homosexuals?

Answering these questions through active dialogue/interaction between teacher and student is just one of several exercises that can be utilized in the classroom. Other activities include keeping diaries or journals that ask students to review various films or other media and to report their findings for discussion within the classroom (Rodríguez 1998). As

we approach a new millennium, it is important that we attempt to integrate media literacy in our classrooms. This should not be seen as being difficult or impossible; more and more U.S. schools are realizing the inherent value of this type of instruction (McGee 1997). It is of the utmost importance that we make our students aware of the dangers of not questioning the negative and/or stereotypical images that are constantly transmitted to us. Assuming that these images are synonymous with reality is to risk forever being the human transmitters of stereotypes about and false images of how those who may be ethnically different conduct life on a day-to-day basis.

References

Associated Press. 1996, April 17. Stereotypes common, but Hispanics' TV image improves. *The Detroit News*, A2.

Barone, M. 1998, January. Who are America's Hispanics? *The Reader's Digest* 152: 116–122.

Byerley, J. 1994. [Review of the film *I Like It Like That*]. Available: http://www.hbo.com

Center on Education Policy. 1998. *Public schools: A place where children can learn to get along with others in a diverse society.* Washington, DC: Center on Education Policy.

Ferriss, S. 1994, September 8. Latino characters either absent or stereotyped. *The San Diego Union-Tribune*, E-5.

Innis, R. E. 1985. *Semiotics: An introductory anthology.* Bloomington: Indiana University Press.

Jiménez, L. 1998. From the margin to the center: Puerto Rican cinema in New York. In *Latin looks: Images of Latinas and Latino/as in the U.S. media*, edited by C. L. Rodríguez. Boulder, CO: Westview Press.

Martin, D. (Producer and Director). 1994. *I like it like that.* Columbia.

Massey, D. S., R. E. Zambrana, and S. A. Bell. 1995. Contemporary issues in Latino families: Future directions for research, policy, and practice. In *Understanding Latino families: Scholarship, policy, and practice.* Thousand Oaks, CA: Sage.

McGee, M. 1997. Students need media literacy. *The Education Digest* 6, no. 1: 31–35.

National Council of La Raza. 1998. Out of the picture: Hispanics in the media. In *Latin looks: Images of Latinas and Latino/as in the U.S. media*, edited by C. L. Rodríguez. Boulder, CO: Westview Press.

Pérez, R. 1998. From assimilation to annihilation: Puerto Rican images in U.S. films. In *Latin looks: Images of Latinas and Latino/as in the U.S. media*, edited by C. L. Rodríguez. Boulder, CO: Westview Press.

Quesada, A. and S. L. Summers. 1998. Literacy in the cyberage: Teaching Kids to Be Media Savvy. *Technology & Learning* 18: pp. 30-36.

Ramírez-Berg, C. 1998. Stereotyping in films in general and of the Hispanic in particular. In *Latin looks: Images of Latinas and Latino/as in the U.S. media*, edited by C. L. Rodríguez. Boulder, CO: Westview Press.

Rodríguez, C. E. 1998. Promoting analytical and critical viewing. In *Latin looks: Images of Latinas and Latino/as in the U.S. media*, edited by C. L. Rodríguez. Boulder, CO: Westview Press.

Romano, M. 1997, October 14. US West chief blasts media on race: Industry aids in keeping Hispanics the target of prejudice, stereotypes, Trujillo says at forum. *The Rocky Mountain News*, 4-A.

Sheehan, H. 1995, May 14. Recent movies perpetuate stereotypes about Hispanics. *The Orange County Register*, F-11.

Superville, D. 1996, April 20. Stereotypes of Hispanics still on TV, study shows. *The Fort Worth Star-Telegram*, 38A.

Chapter Nine

Critical Media Literacy and ESL/EFL Classrooms

Arda Arikan

The use of media in foreign language classrooms has b een recognized as a powerful tool for teaching. Media open up spaces to practice language within a pool of cultural artifacts that are already known to students through TV, radio, movies, songs, and literature. Even though to date there are many volumes of research and books on media literacy, few have integrated English as a second language (ESL) or English as a foreign language (EFL). The aim of this chapter is to explore how media literacy can become a critical project in ESL/EFL classes that are in countries other than the United Kingdom, Canada, or the United States. Media literacy refers to an act of "knowing" within a specific critical stance that rejects the idea of an isolated neutral/objective reality while collaboratively constructing realities under sociohistorical influences (Gallagher 1993). This chapter addresses critical literacy in ESL/EFL classrooms by applying a critical theoretical framework taken from teaching about media and English language teaching research.

Theoretical Framework

An evolving body of literature strengthens a new classification of literacy in the academia. Some scholars think that traditional definitions of literacy are narrow and limiting because literacy is confined to reading and writing skills. Critics support a new and broader definition of literacy that includes other literacies, such as being able to read, understand, and discuss other forms of texts, including visual and audio-lingual texts and cultural artifacts, experiences, and written pieces (see, for example, Lankshear 1994). In his preface to *Rethinking Media Literacy*, Kellner

argues that critical literacy is more than acquiring the rudimentary skills of reading and writing:

> Functional literacy refers to the acquisition of the rudimentary skills of reading and writing, while cultural literacy refers to acquisition of basic knowledge concerning one's culture, society, and polity. These are the concerns of standard pedagogy. Critical literacy, by contrast, refers to the gaining of skills necessary to analyze and critically dissect all the forms of culture with which individuals interact, ranging from books to the artifacts of film, television, radio, and the other products of the cultural industries. . . enabling people to create their own meanings, identities, and to shape and transform the material and social conditions of their culture and society. (xiv)

The introduction of media literacy into the study of critical literacy urges educators to take a closer look at the simplistic definitions that have been used for decades without being questioned. Kellner's argument is supported by critical theorists who have emerged in the fields of education, cultural studies, anthropology, and in media and communication studies (see, for example, Giroux, Simon, and Contributors 1989; Freire 1985; McLaren, Hammer, Sholle, and Reilly 1995). Many studies have emerged on the use of media artifacts in the teaching of English as the second language (ESL) and in the teaching of English as a foreign language (EFL). However, most of these quantitatively limited ESL/EFL studies lack an analysis of power relations. Traditional approaches are silent about how knowledge and power work together to silence or marginalize students in various contexts. While applying critical media literacy in classrooms, therefore, all texts must be regarded as sources that carry shifting meanings in time and contexts and reflect cultural ideologies that need to be uncovered (Semali and Pailliotet 1999).

Why Media Literacy in ESL/EFL Classes?

We have witnessed a shift from teacher-centered language teaching and learning to student-centered practices (Kumaravadivelu 1994). As teachers of English, we have tried new methods and activities to create student-centered classrooms in which students were the measure as well as the active agents of the language-learning process. Hands-on, or the so-called learning by doing, philosophies have replaced our syllabi, yet not much has changed in the role of the teacher despite nationwide changes in language teaching curricula. For instance, from Tunisia to Taiwan, and from Argentina to Eastern European countries, many governments have tried

to standardize language teaching and learning practices in light of new theories and methods. These changes are taking place within the influence of the communicative language teaching paradigm that have found inspiration and direction in the interaction of initiatives, both theoretical and applied, in many different cultural and national contexts (Savignon 1997).

When the influence of communicative language teaching paradigm on our own teaching is considered, we see a dramatic shift from traditional teaching techniques to newer models of and attitudes toward language learning. This shift, which seeks more social ways of teaching and learning, embraces the world outside and prepares the language learner in the classroom in such a way that the student experiences the target culture and language in the classroom as a rehearsal for the real life (Savignon 1997). This attitude can best be contrasted with the traditional methods that have been criticized for being decontextualized. Bateson exemplifies the notion of this traditional language teaching methodology as teaching of isolated entities rather than parts of the whole that are multiple and fluid in their nature.

> Children in school are still taught nonsense. They are told that a "noun" is the "name of a person, place or thing," and a "verb" is "an action word" and so on. That is, they are taught at a tender age that the way to define something is in itself, not in its relation to other things. (McLaren et al. 1995, 35)

These changes in how we understand education and language teaching are also articulated by social reconstructionists who ask for a positive social change that can be achieved through educating students to assume a critical stance that they can apply in their real lives. Social reconstructionists often make use of print materials such as newspapers, music pieces, and television programs that are relevant to students' lives in order to show social injustice and the status of various groups in the society (Kliebard 1995). It is believed that it is not only the societies of the English speaking world that we, the ESL/EFL teachers and instructors, should analyze and teach within a critical stance, but we have to do it for our own societies which cannot be separated from the rest of the world. However, we have to be aware of the fact that referring to social things and cultures that are multiple and diverse in nature often creates a greater problem for us in the context of the issue of media bias. Certain questions spring from the value-rich problem of media bias, some of which are: How realistic are these representations? Who creates and ben-

efits from the representation/knowledge produced? What are the effects of these representations on the individuals who are exposed to these materials? What are the effects on the society?

Contemporary research on English-speaking communities refers to the fact that there is no single standard language or usage of English in the English-speaking world (Ayers 1993; Crystal 1998; Wardaugh 1999). Using classroom materials that transmit a single "standard language" to differentiate among other cultures and individuals within the English-speaking community apparently not only distorts the realities of these groups but also puts our language learners in a difficult position for their future contact with the English-speaking world. This misleading practice which occurs in many ESL/EFL classes has been a major concern in literature and is often named as stereotyping. Stereotyping is a common fallacy that disrupts the process of learning a language and cultures (Ayers 1993; Cohee, Daumer, Kemp, Krebs, Lafky, and Runzo 1998; Hall 1997; Tiedt and Tiedt 1990). Because of concerns about stereotyping, teachers often feel uneasy about adding cultural aspects of the language in their classrooms, particularly when social unrest is a factor in the countries that the language is being taught. For instance, many ESL/EFL teachers who work in countries that prohibit free expression of personal and social identity feel uneasy about talking about media representations of religious, political, or cultural diversity. While, as Slocum (1997) argues:

> Media bias affects all aspects of our lives. Women are seen as sex objects that need to be controlled by men. African Americans are usually taking drugs, committing crimes, or on welfare. Arabs are terrorists. Jewish people are cheap and try to cheat you in business. Gay men are promiscuous. Disabled people are asexual. These are all common stereotypes that are found in media messages everyday. (19)

Why do we insist on putting media literacy in our ESL/EFL classes in the face of mentioning all these problems and concerns? I think the answer lies in recent attempts to bring real life into the classroom in order to provide a life-like context in which to learn language. A question arises: How are we going to treat the classroom as a rehearsal for real-life contexts? How can we exemplify the lives of individuals and groups living within the United Kingdom, the United States of America, Canada, and within the countries in which English is the dominant language? How can we represent these groups with their social and cultural aspects that are essential in students' language learning experiences?

Some privileged schools and institutions are trying to solve this problem by bringing native speakers of English to their countries as language teachers. This strategy has limitations; one individual doesn't constitute the whole social system. Perhaps this problem could be addressed by the use of media. Media that present native speakers of English through movies, songs, newspapers, magazines, the Internet, and radio could be utilized broadly. That is to say, EFL teachers whose native language is not English could use this practical solution to solve the culture and language gap. Bringing the media products of the English-speaking countries (which are already available through the television, radio, etc.) into our classrooms could introduce students to authentic language use.

But this method of introducing media as audiovisuals for cultural learning does not in and of itself constitute a critical literacy project. To introduce critical media literacy in the ESL/EFL classrooms, teachers must not consider the mere presence of media artifacts (play, songs, films, etc.) to be sufficient. Instead, they must endeavor to teach *about* these media as well as *with* them. Students need to be engaged as they learn the communicative powers of the target language as well as its constructedness; its conventions; its connection with industry, especially with advertising; its value-laden messages; and its aesthetic characteristics. It is through questioning of these media that ESL/EFL students find the opportunity to engage in a critique of the culture while learning how the language works.

Here are some important reasons to teach about media representations in our classes through critical inquiry as outlined by Slocum (1997):

1. LACK OF FAMILY INTERVENTION: If the family hasn't done primary teaching about media representations, and often they have not, the responsibility falls on schools.

2. PROMOTION OF CRITICAL SKILLS: Students should be enabled to think for themselves, and since the media constitutes a large part of a student's life, it needs to be addressed.

3. BRIDGING BETWEEN THE CLASSROOM AND THE REAL LIFE: Media literacy can enhance real-life learning rather than textbook learning, which tends to be more academic and less contextual.

4. IMPACT OF NEGATIVE MEDIA PORTRAYALS ON STUDENTS' SELF IMAGES: If the classroom is a sample of the whole society, then we are likely to have students from diverse communities, sexual orientations, and religious and cultural backgrounds that are misrepresented or negatively portrayed by the media. How do these images affect them?

In short, I advocate the use of media materials in classrooms by language teachers because they can provide a direct means for English learners to envisage real-life situations and authentic language use. In my own teaching, I have often been surprised to find that many ESL/EFL students know a lot about American or British pop singers, Hollywood shows, and programs. In almost every classroom, the students were exposed to print advertisements from tobacco companies or auto manufacturers that are American or British. Even in less privileged countries, our students see or hear about Red Cross volunteers or missionaries or United Nations workers that are American. All of these examples provide opportunities to make contacts with the English language in ways that could be engaged authentically. Such contacts include news broadcasts we hear about these groups, news that we can analyze in our own ESL/EFL classrooms. How would a teacher utilize these materials in a critical media literacy context?

How Can We Teach about Media in the ESL/EFL Classroom?

I believe that the best and the easiest way of starting a language class about a media product is to ask students the meanings they gather from that specific product or message to elicit the effect of the media product on the receiver. It is the easiest way for me instead of starting with a lecture. The students will gain control over the lesson and can further develop the discussion, activity, or the lesson as a whole without much help from the teacher. In addition, there remains a dilemma that the teacher faces as Hart (1998) cites Tyner:

> Teacher response to popular culture ranges from trashing it to embracing it. If teachers criticize popular communication forms, they run the risk of alienating and insulting the very culture that students value. If they embrace it, they risk looking like ridiculous fuddy-duddies who are trying too hard to appear up-to-date. . . . In the course of walking this tightrope, it isn't necessary for teachers to suppress personal distaste for popular cultural artifacts, or to express glowing enthusiasm for every new pop culture trend. (187)

The role of the teacher as the mediator is difficult for several reasons. First, the teacher must switch back and forth between his or her ideology and academic knowledge. Second, how will the teacher deal with students' feelings or reflections that they bring to the classroom? This situation can be complicated by the fact that it may well be the first time that students have been pushed to think critically about their favorite programs or media icons. To overcome these difficulties, it may become necessary to have a teacher use a dialogic (two-way) approach and also use his or her knowledge base. In this phase, the critical thinking activities the teacher introduces can help students transfer this way of thinking to a critique of media products. Harpley (1990) starts critical thinking activities about media products with students who are as young as five years old. His questions include the following:

1. What sort of text is it? Is it a drawing or a photograph?
2. Is there a story implied in the picture or is it a straight picture of the product?
3. Does it appeal to the emotions? Does it encourage competitive feelings like "I must have that to be like everyone else"?
4. What clues do we get from the location, clothing, colors, materials, and people?
5. Who has made the decisions while creating this media product? Does it give a real, honest view of the product? How are these claims made by comparisons, scientific studies, people's recommendations, or research?
6. Who are the viewers or readers? Are there any other ways of feeling or categorizing the product? What are they?

In addition to Harpley's questions, there are more detailed lists of questions produced by other media specialists that offer an in-depth inquiry about media representations, such as those developed by Silverblatt (1995). Even though his list is too complex to explain here in detail, there are four main categories that might be relevant to this discussion of how to deconstruct media messages and images:

1. PROCESS: The purpose, characteristics, owner/producer, audience, and strategies behind the message.

and discourse-based activities. (After the critical media activities, your students can reenact or reproduce these materials with what they learned in the critical thinking session that you have taught.)

7. INTEGRATE LANGUAGE SKILLS: Pull reading, writing, listening, and speaking skills together rather than teaching them in a way that isolates and fragments them. (You can ask your students to take notes while watching or listening to the material, or if it is a print material ask them to discuss it and respond to classmates.)

8. PROMOTE LEARNER AUTONOMY: Since your student is going to be on his or her own in language learning and use in real life, empower him or her to be able to create and trust his or her own language destiny. (Make your students produce their own reflections about the material while reshaping and changing it or while commenting on it.)

9. RAISE CULTURAL CONSCIOUSNESS: Elicit and reach a synthesis among the learner, her home culture, and the target cultural objectives. (Treat your contextual media materials the same as other "target culture" materials. This will also increase student motivation.)

10. ENSURE SOCIAL RELEVANCE: Be sensitive to the societal, political, economic, and educational factors that shape the environment where you teach. (Here is the most important consideration for the safety and well-being of the teacher. Realize that applying critical skills and asking many questions that generate thought about political, sexual, traditional, and cultural topics may bring dissatisfaction or concerns from the parents or from the principals. It may help to wait until students are comfortable with critical analysis before you introduce controversial topics, and always make sure that when you address these sensitive topics you use ESL/EFL methodology correctly. Share the ESL/EFL documents in support of what you are doing in the classroom.)

To conclude this chapter, let me return to Layzer and Sharkey's (1999) EFL experiences in a Japanese EFL classroom. After teaching there for two years, they concluded:

> Students come to the classroom with a vast storehouse of cultural information to be mined for insights. Through a course in media literacy, the process of excavation and analysis can be initiated. (169)

They indicated that one of the factors that made their experience successful was that their course was a relatively safe site for ideological contestation but it was very rich in meaning-making. This, as they reflect, could be done better in a similar classroom through a more in-depth exploration of notions of culture and identity formation. This reflection gives the responsibility to the teacher to learn more about these issues, which serve as the toolkit of the instructor who is teaching in such a project.

To sum up, it seems to me that every ESL/EFL teacher will create her/his own critical media literacy curriculum to foster a better language learning and practice. The environment must be appropriate for the students' ages. Other factors might consist of availability of the materials and the political and social situation of the context of teaching. Critical media literacy provides students with the most up-to-date information relevant to the students' own target language and their own sociopolitical, cultural, and linguistic realities. Students will be empowered through critical media literacy to understand how these realities shape their learning and they will also be empowered to understand how these realities are created and what forces stand behind their production.

References

Ayers, W. 1993. *To teach: The journey of a teacher*. New York: Teachers College.

Cohee, E. G., Daumer, E., Kemp, T. D., Krebs, P. M., Lafky, S. A., Runzo, S. (Eds.). 1998. *The feminist teacher anthology*. New York: Teachers College.

Crystal, D. 1998. *English as a global language*. Cambridge: Cambridge University Press.

Freire, P. 1985. *The politics of education: Culture, power, and liberation*. Westport, CT: Bergin & Garvey.

Gallagher, S. 1993. *Hermeneutics and education*. Albany: State University of New York.

Giroux, H., Simon, R. I., & Contributors. 1989. *Popular culture, schooling, and everyday life*. New York: Bergin and Garvey.

Hall, S. 1997. *Representation. Cultural representations and signifying practices*. Thousand Oaks, CA: Sage.

Harpley, A. 1990. *Bright ideas: Media education*. Warwickshire: Scholastic Publications.

Hart, A. 1998. *Teaching the media: International perspectives*. Mahwah, NJ: Lawrence Erlbaum Associates.

Kliebard, M. H. 1995. *The struggle for the American curriculum*. New York: Routledge.

Kumaravadivelu, B. 1994. The postmethod condition: Emergent strategies for second/foreign language classroom. *TESOL Quarterly* 28, no. 1: 27–48.

Layzer, C. and Sharkey, J. 1999. Critical media literacy as an English language content course in Japan. In *Intermediality: The teacher's handbook of critical media literacy*, ed. L. Semali and A. Pailliotet. Boulder, CO: Westview.

Lankshear, C. 1994. *Critical literacy*. (Occasional paper no. 3, pp. 4–26.) Australian Studies Association.

McLaren, D., Hammer, R., Sholle, D., Reilly, S. 1995. *Rethinking media literacy*. New York: Peter Lang.

Savignon, J. S. 1997. *Communicative competence: Theory and classroom practice*. New York: McGraw-Hill.

Semali, L. M. and Pailliotet, A. W. 1999. *Intermediality: The teacher's handbook of critical media literacy*. Boulder, CO: Westview.

Silverblatt, A. 1995. *Media literacy: Keys to interpreting media messages*. Westport, CT: Praeger.

Slocum, K. J. 1997. *Media literacy in the secondary language arts classroom: The Penn State experience*. University Park: Penn State University.

Tiedt, L. P,. and I. M. Tiedt. 1990. *Multicultural teaching: A handbook of activities, information, and resources*. Boston: Allyn and Bacon.

Wardaugh, R. 1999. *Proper English: Myths and misunderstandings about language*. Malden, MA: Blackwell.

Chapter Ten

Who's Running the Show? Deconstruction of Gender and *Ally McBeal*

Sarah Green

Oscar Wilde said it best: Life often imitates art. Imitation or replication, if you will, of cultural representations of identity has begun to cause scrutiny about preconceived definitions of gender. Each decade seems to have an ever-morphing sense of what it is to be man or a woman. In the 1950s, women were housewives and men were wage-earners. In the 1960s, women's liberation and sexual awakening were the themes. In the 1970s, women entered the workforce and the emotionally sensitive man appeared on the scene. In the 1980s, the 1950s housewife merged with the career woman and men were encouraged to be strong like Rambo. By the 1990s, the lines between male and female gender roles had blurred into a unisex cyberspace world.

These images are usually both guided by outside cultures and influenced by the increasing power of the media that serves as the teller of our stories and the lens through which we see ourselves. Noreene Janus (1996) maintains that the time is now for a critical perspective with which to examine the sex roles promulgated on television. "[It] will demonstrate not only that the women in the media are inferior to men, but also the limited and demeaning images of women are structurally related to the functioning of capitalism" (Janus 1996, 9). In essence, the audience wants what they want: strong men and women in familiar roles that either encourage or outrage or entertain.

In the high school classroom, what place does analyzing gender roles in media have to do with analyzing history, science, and English? This is a question I frequently asked myself when I first encountered this line of thinking. The critical semiotic perspective aligns itself with subject curriculum in several ways. For the teacher, it gives a new framework from

which to stimulate discussion or debate or written analysis with their students. For the student, it challenges the familiar argument that "what we learn here is not part of the real world." The media messages and images that students come in contact with every day can be used as texts to be challenged, deconstructed, and refocused, just as the print texts that students may use in the classroom as part of the curriculum.

In this chapter, I will apply Fiske and Hartley's (1978) critical semiotic model of the Bardic Trap to a television show with a female protagonist that reflects one perspective on gender roles, *Ally McBeal*. This show, created by David Kelley, is presented as a comedic melodrama about a female lawyer and her friends and co-workers. It has resonated with viewers because of its reality-based story lines about "being in love and dating and still be able to maintain a successful career as a woman in the workplace" (Chambers 1998, 58). Not since *The Mary Tyler Moore Show* in the 1970s has a show given such prominence to the working woman and her emotional ups and downs (Dowd 1998). Yet with this praise comes the criticism that although the character of Ally is heralded as a strong modern 1990s woman, she is still portrayed as the emotionally helpless sex- and love-driven erratic female.

In my own youth in the early 1980s, the soap opera *Days of Our Lives* was very popular. I dreamed of myself playing the roles but doing things differently than the characters so that my own soap-opera ending would be better. I learned how to create the smokiest eye and the fullest lip and how to flirt with and catch a dangerous man. The images reflected my own insecurities and strengths as a woman; that was why they were so important to me. I saw them as more than pure entertainment. However, when the media notices a political issue on the rise (as they did on *Murphy Brown* in the 1980s with the issue of single mother/career woman) or receives input from both audience and advertisers about what both sexes want to see in their male and female characters (witness Ally McBeal as an emotionally insecure yet career-oriented female lawyer), they either magnify the idea or exaggerate it to the extreme for "entertainment value." The dominant cultural values about what men and women should be doing are reflected in media portrayals.

An analysis of the show's gender roles from a critical perspective must begin with an examination of the principles of entertainment. Teaching students to look at television as a constructed medium will help them make sense of changing attitudes toward gender roles and will push them to ask questions about how television discourse is produced. Part of

the value of *Ally McBeal* for women who relate to her is the discourse that
she as a character creates. Mary Ellen Brown calls this type of discourse
a network of possible ways of speaking, of being spoken about, of being,
of belonging, of empowering, and consequently of socially and physical-
ly enforcing normalcy. In other words, the ways that people can live, their
social practices, are "constructed" by the way these practices can be spo-
ken about or conceptualized in language (Brown 1989a).

The discourse that the show *Ally McBeal* produces as a result of a
constructed character is the defining line for renewal and viewer loyalty.
Viewers who watch the show identify with or want to be Ally because
the character is an amalgam of single working women or lawyers or
young women in the dating scene. David Altheide and Robert Snow
(1979) say that in the production of media "the definition of the situation
ultimately lies with audience response." The impact of this idea on the
viewing public is not always the intended one, and most of us who make
up the audience are not as critical as we might want to be about what we
see or hear or download as a result of our ever-changing tastes and
trends. Men and women who watch, read, and/or identify with the con-
structed images they are given by the media do not realize what they are
actually given. They just assume that each fresh new character or story
line or brand-new show is what they asked for or they accept the expla-
nation outlined by the creators or reviewers of the show or character.
These new media products may just be reversed stereotypical gender
roles with the packaging replaced or updated. Even through the new set
of television shows, films, and music that try to restate that the 1990s
woman or man will once again be improved or enlightened, the reversion
back to what was popular or considered mainstream only ten to twenty
years ago is still underneath. The resurgence of retro or past-revisited
shows, books, or movies is one of the major contributors to this well-pre-
sented front of "modern" living.

Brown remarks that "cultural studies offer an analysis of how ideol-
ogy is produced and functions within television products and practices
and how audiences use and interact with television in their lives. Its aim
[is] understanding and empowerment" (1989a, 14). Two interpretive
models are useful as we begin to analyze *Ally McBeal* on the one hand as
a discourse, a social exchange of language and symbols, and on the other
as a constructed product, a pre-conceived concept that changes with each
new outside influence. I will use John Fiske and John Hartley's model of

the Bardic Trap as well as the feminist postmodern viewpoints of Mary
Ellen Brown's work on television and women's culture.

The Bardic Trap and Postmodern Feminism

Fiske and Hartley (1978, 88) define the Bardic Trap as a type of enter-
tainment that television provides. Television is the "bard" who arrives in
living rooms each day or night to spin a tale of fantasy and/or reality that
intrigues the audience. Their model outlines seven roles that television
plays when attracting an audience:

1. It *articulates* the main lines of the established cultural consensus
 about the nature of reality.
2. It *implicates* the individual members of the culture in its domi-
 nant value systems.
3. It *celebrates*, explains, interprets, and justifies the doings of the
 culture's individual representatives.
4. It *assures* the culture at large of its practical adequacy in the
 world.
5. It *exposes* any practical inadequacies in the culture's sense of
 itself.
6. It *convinces* the audience that their status and identity as individ-
 uals is guaranteed by the culture.
7. It *transmits* by these means a sense of cultural membership.

Postmodern feminism is a way for feminists to "continue to question
and undo the patriarchal construction of femininity, to pose the problem
of representation, to demonstrate the social constructions of gender" and
therefore reach a level of questioning that can be used to break apart what
is established as reality (Kaplan 1996, 35). If we refocus Fiske and
Hartley's model through Brown's postmodern feminist notion of gender
transgression, or behavior that crosses the lines of what hegemonic cul-
ture deems appropriate for men and women, we get a framework that is
workable for television shows such as *Ally McBeal*. I suggest that stu-
dents and teachers use this analytical framework to begin to problematize
the constructed character of Ally.

To articulate the cultural consensus about a character who has the
desire to succeed and do well (which is selected as the male trait) as long
as it is with a cute boyfriend (selected as the female trait), the character
of Ally and her various friends and co-workers seem to interact in a way

that includes a communication style that is seemingly unrelated to gender. This is one of the traits of gender transgression. Ally's character is able to talk to either gender in their own language and assist not only them but also herself with emotional issues and social problems. Sometimes the show reinstates formats and formulas from the past in order to show us how much we have progressed in our self-images of gender. Ally still has her own personal issues with the conflict between her romantic life and her image at work. Critics of this blending of issues tend to suggest that "[Ally's] attitudes toward sex and work represent the dark side of do-me feminism; where wholesome carnality shades into careerist cunning" (Shalit 1998). The program on occasion shows her in a less-than-positive light when it comes to her own relationships. She is usually so insecure or so involved with her friends and cohorts that her own life seems to suffer for it. Critic R. Shalit notes that "David Kelley has set things up [so that] Ally's imbalance is a badge of honor. . . . Her girlish indifference to such manly concerns as law and logic and reason do not just make her a superior person" (Shalit 1998). She also dresses in shorter skirts and bright lipstick, perhaps to remind the audience that she still has a woman's concerns about appearance. So where is the balance here between Ally the woman and Ally the lawyer and, even more importantly, Ally the person?

In other words, is Ally accomplishing her goal of capturing the 1990s image of a working woman while keeping in mind what it means to be a cultural icon? Students relate very easily to the constructed two-dimensional image on their television screens, but often they tend to ignore the shadow image, the image that is left out, the negative print, if you will, of television characters. Within a postmodernist construction, the image we see is put together according to the guidelines of the current power structure. The media changes images of the power structure in order to please viewer taste. The hidden image is what we as viewers are missing when we are distracted by the initial image. Students can first begin to question Ally's image by looking at what is being marketed to them as an audience. What is the creator trying to sell them as entertainment? Other questions could include:

a. How was Ally chosen? What about her is important for the appeal of the show?
b. To whom does she appeal most? Why? What about the construction of this character creates this appeal?

c. Whose purpose is she serving, hers or the writers'? How is this done?
d. Who is missing from this appeal? Who does not get represented in Ally's world?
e. Why would the writer choose to erase these people from Ally's world?
f. What do you think the writer is really saying here about Ally and her persona?

It is important to keep in mind that the constructed world of *Ally McBeal* ignores race and sexual preference. Ally focuses on her career, since the show is centered on her office and the people in it; her skill as a professional when she is in the courtroom and planning a case; and her reactions to emotional contact (whether it be her own or others), usually punctuated with special effects and a great deal of self-musing that we hear as voice-overs.

The Bardic Trap model is a good tool with which to initiate the second phase of questions about the character of Ally McBeal:

a. What is Ally attempting to articulate through her actions rather than her words?
b. What kind of assurances does she and her co-workers make to explain their actions and exchanges?
c. How does the character of Ally celebrate her strengths, or does she focus mostly on her weaknesses?
d. Does she or any of her situations expose truths or questions about race, class, or gender that were not apparent to the audience before?
e. What is the creator trying to convince or transmit to his audience about roles of women and men at work or in their personal lives?

It is important to note that the show does not address the question of the Other. Non-White or non-heterosexual people appear on the show only as professionals, such as Ally's roommate's African-American doctor boyfriend. Ally's clients are White and middle class.

Now let us add a postmodern feminist lens. What gender issues does Ally contend with at work? First, although Ally works quite successfully within the very male context of the law firm, she seems to be blocked by three gender-related issues. The show's producers have constructed her

such that she cannot get past her feelings for her ex-boyfriend, his new wife, and her boss (who is secretly in love with her but will not declare himself because he does not want to create an awkward professional situation for her or raise the specter of her experience of sexual harassment at her first law firm). These issues carry the show and supposedly make all the necessary transitions to enable viewers to follow Ally from dilemma to dilemma.

The other side of the coin here is the hidden image behind this picture. This third questioning phase hopefully will surface once the first two initial analyses are done to show the frailties in Ally's character. Through the first two presented frameworks, students should recognize what might be missing from Ally's supposedly three-dimensional persona:

a. Where is Ally's family?
b. Are we to assume that she comes from a stable family with two parents and a family pet?
c. How about siblings?
d. Why aren't these issues factors in her ability to relate to people in the show?

The next focus might be on her youth. As part of her appeal, Ally is relatively young. Is she fresh out of law school? Has she always practiced in this firm? Is this her first job? Finally, one of the last focuses might be on the interesting parallel between her present social and/or cultural problem and whatever case she seems to be trying in court. Some element of the case always seems to overlap with her personal issues in order to produce one of two endings: resolution of the issue at hand or further questioning by Ally or the other lawyers involved. This technique offers a smaller discourse within the larger one that viewers become attached to and perhaps translate into their own lives. These questions raised here could further be examined through other concepts such as multiculturalism, historical trends, or even gender-role reversal—the male characters are viewed only through Ally's eyes and do not seem to develop outside that view.

I am not suggesting that all this terminology should be considered as a panacea that will erase or soften the lines drawn between genders, but I do ask what the list of characteristics is that should be made for the future. Brown remarks on women's roles in terms of the discourse between women and what they watch as a "balancing act between their own lived

experiences and what public or naturalized versions of these roles or experiences represent" (1989a, 202). When students analyze popular television programs, they can identify the hidden or "negative" image of the programs. Students need to see beyond the two-dimensional pictures on their television screens, and they also need to work to understand where ideas about gender roles have been and where they are taking us.

References

Altheide, D., and R. Snow. 1979. *Media logic.* London, England: Sage Publications.

Brown, M. E. 1989a. Feminist culturalism and television criticism—Culture, theory and practice. In *Television and women's culture*, edited by M. E. Brown. London: Sage Publications.

Brown, M. E. 1989b. Consumption and resistance: The problem of pleasure. In *Television and women's culture*, edited by M. E. Brown. London: Sage Publications.

Chambers, V. 1998. How would Ally do it? *Newsweek* (March 2): 58–60.

Dowd, M. 1998. She-TV, Me-TV. *The New York Times* (July 22): A19.

Fiske, J., and J. Hartley. 1978. *Reading television.* London: Methuen and Co.

Janus, N. 1996. Research on sex roles in the mass media: Toward a critical approach. In *Turning it on: A reader in women and media*, edited by H. Baehr and A. Gray. New York: Arnold Publishing.

Kaplan, E. A. 1996. Feminism/Oedipus/postmodernism: The case of MTV. In *Turning it on: A reader in women and media*, edited by H. Baehr and A. Gray. New York: Arnold Publishing.

Shalit, R. 1998. Canny and Lacy. *The New Republic* (April 6): 27–32.

Chapter Eleven

Afterword: Semiotic Assumptions in the Social Practice of Critical Literacy

Jamie Myers

The preceding chapters offer a range of strategies that all teachers can use to expand students' critical consciousness and thereby heighten their agency in the social construction of their identities, relationships, and values. These strategies are based in social theories of knowing and being in which one's meaning in the context of the self, others, and the world is a consequence of participation in the social interactions and activities valued within a particular cultural world (Blumer 1969; Vygotsky 1981; Lave and Wenger 1991; Dewey 1963). Within this everyday activities and social interaction, signs and symbols are used in culturally negotiated and patterned ways called literacy practices, and these practices carry particular forms of skill, action, and thinking that support the activity or interaction (Bruner 1986; Street 1995). Acts of literacy using any system of symbols or signs (talk, gesture, dance, music, art, print, etc.) are purposeful within the social practice, and a specific act of literacy might accomplish very different ends in different practices. Scribner and Cole (1981) explain that social practices consist of more than traditional reading and writing:

> Literacy is not simply knowing how to read and write a particular script, but applying this knowledge for specific purposes in specific contexts of use. The nature of these practices, including of course their technological aspects, will determine the kinds of skills (consequences) associated with literacy. (136)

In this vein, we realize that in everyday activity we can be in the midst of many overlapping, often contesting, literacy practices, each valuing particular identities, relationships, and beliefs. In the midst of these cultural contexts we mediate our meanings for the world, others,

and ourselves the signs and symbols we wield to produce texts so that we might have the very sense of being alive. The social literacy practices through which we mediate all meaning by wielding signs and symbols are highly transparent. The activities of transmediating texts from one symbolic system into another advocated in this volume support the construction of critical literacy practices by filling the space between the first and second text with an examination of the underlying cultural ideologies that form the *intertextual* web of all semiotic meaning.

It is particularly significant that many of the chapter authors describe successful critical literacy work (across all media) with five- and six-year-olds as well as ESL students, because traditionally these populations are defined as deficient in language skills, incapable of engaging in any critical discussion of textual meanings. Such innovative thought rejects our common skill-based pedagogical practices in which literacy activity involves learning neutral decoding/encoding skills to derive single and immutable meanings from any text. Through the classroom stories and interpretive frameworks, the authors describe how to construct with students (and the "with" is part of what makes it a critical social practice) critical literacy practices that bring texts, the worlds they represent, and *consciousness* into an ideological relationship. These socially constructed literacy practices are precisely those encouraged by Street (1995) as the basis for a more democratic and just society:

> Every literacy is learnt in a specific context in a particular way and the modes of learning, the social relationships of student to teacher are modes of socialization and acculturation. The student is learning cultural models of identity and personhood, not just how to decode script or to write a particular hand. If that is the case, then leaving the critical process until after they have learnt many of the genres of literacy used in that society is putting off, possibly forever, the socialization into critical perspectives. (140)

Using transmediation of texts as the basis for generating critical literacy practices holds significant promise in the teaching of critical perspectives to students of the twenty-first century. However, the act of translating a text from one sign system into another and of itself does not necessarily generate any critical examination of the underlying ideologies supporting the meaning of either text. Students are more accustomed than teachers to producing texts in schools that achieve prescribed formats as ends in themselves. We often do not recognize how a text and its meaning functions within a social practice to produce particular values, roles,

relationships, traditions, and beliefs. Therefore, this afterword explores assumptions about meaning and being from a semiotic perspective. I hope to facilitate the pedagogical consciousness required to construct critical media literacy practices.

Assumptions about Consciousness and Agency

My hope itself reveals the first semiotic assumption—that consciousness about the world increases the potential for personal happiness and social justice in everyday participation in the world. Throughout this volume, talk about the world and talk about the texts that represent or misrepresent the world is supremely valued. In Chapter 3, first-graders talk about the exclusion of their regular everyday clothing from the Barbie catalog. They discuss how chores at home can be done by either gender but are often defined as "boy" or "girl" chores. These nonlinguistic signs (clothing) and nonlinguistic symbolic activities (chores) are interpreted or, as semioticians will say, are mediated by linguistic texts (talk) about gender to construct a consciousness that in the future will reframe (transmediate) both linguistic and nonlinguistic signs in terms of gendered relationships and identities. Transmediation generates a space for critique even when a linguistic text is re-represented in a new linguistic form.

A semiotic perspective includes consciousness that is not linguistic. In fact, we live through a consciousness that fluidly and transparently blends all nature of signs. But it is the linguistic sign that is more malleable. Yes, we can change the spatial arrangement of objects in our lives and the objects can gather layers of meaning from each moment of experience in which they are contextualized. But we can change words in a flash and imply multiple meanings in one metaphorical utterance. We rely heavily on language to fix and share ideas across people, time, and space. And in that fixing we draw a large share of our consciousness.

In Chapter 2, Fueyo highlights how difficult it is to turn off the constant play-by-play commentary running in our minds that is almost universally considered to be our consciousness. It should not be difficult to understand why school literacy practices are so dominated by linguistic texts and activity. And while we want to engage a fuller critique of our nonlinguistic textual lives, we may not want to construct this critique solely as a linguistic practice. Likewise, in Chapter 4, Chang illustrates in detail how play and art continue to be excluded from the formal school curriculum even though children use these avenues as important pedagogical tools. We should work hard to provide extensive opportunities for

literature, gesture, video), forms the basis of the semiotic assumption that all meaning is relational, not embedded (or entombed) within each single text. While the authors of this volume encourage teachers to construct critical media literacy practices with students, the process is often illustrated as simply exposing particular texts as misrepresentations of life experience. From a semiotic point of view, nothing is a misrepresentation; everything is an ideological representation. Each sign is capable of being simultaneously embedded in an infinite number of political agendas. Particular signs become infused with specific meanings because of their constant use in social activity, but they do not possess inherent truth or falseness. While I agree with Antrop-Gonzalez in Chapter 8 that the representation of ethnic identities in popular movies is highly problematic, the most important focus for critical literacy would be the explication of the intertextual webs of racist and sexist ideology that are constructed through the text and an exploration of the social and political contexts that make these films profitable or even logical to produce. Teachers should be careful as they critically deconstruct a text that they do not reinforce a literacy practice in which texts hold meaning, but it is just a question of who can explain the right and wrong, good and bad, meanings of the text.

Enacting such a relational assumption about meaning is difficult in our everyday social interactions and within our school literacy practices. We often admonish people to say what they mean and mean what they say. From the beginning of school, words are taught to have definitions that hold across all contexts of use. This dyadic relationship of sign to meaning is a consequence of our continuous social interaction in which we conventionalize symbolic meaning to construct our own sense of being and stable identity over time and space. To some extent, we accept the possibility of multiple identities across different human relationships; within school we live within social practices that embrace consistent psychological identities.

While we engage in literacy practices in which meaning is dyadic, meaning is always simultaneously triadic. Our own play with signs provides us with ample evidence of the enduring triadic nature of meaning. Everyone has at some time in their lives been involved in a conversation with three or more people in which a statement or action has multiple meanings, one of which can only be interpreted by one other person because of prior shared experience. In every experience, we layer the possible meanings of a sign using all the relational intertexts that we believe would serve our ideological purposes of the moment. Then we work for-

ward in time/space in symbolic interaction with others moment by moment to build the intertext (ideology) that best mediates the meaning created by the signs in this context. In Chapter 2, Fueyo's need to return to the windmill and paint it in exactly the same light as a prior day illustrates how we work the signs of the world into the relations that suit the ideological meanings we seek.

Pierce's classic definition explains that "a sign is something (sign) that stands for something (object), in some respect or capacity (interpretant)" (quoted in Eco 1979, 180). A sign might stand for many things, even simultaneously, but each meaning is grounded by a different respect or capacity. A semiotic meaning is based in a triadic relationship that goes beyond the simple dyad of a text and its meaning. It is in the thirdness that meaning only arises through the intertextual web of relations between signs. The critical media literacy practices illustrated in this volume encourage us to articulate this ideological thirdness to prevent texts from creating and sustaining fixed meanings that marginalize our possible identities, consciousness, and agency.

An important caution is in order. In most interpretive practices, people recognize that the meaning of a text is mediated by the life experience of the reader/viewer. What becomes problematic is when the reader/viewer's life experiences embrace marginalizing ideologies that reinforce problematic representations in the text. Critical literacy practices emphasize mediating a text's meaning in terms of ideological intertexts that oppose race, gender, and class inequities and injustices. First, a semiotic perspective on meaning would invite the negotiation of all possible meanings for a text, not by debating the truth of the text but by discussing the value of the underlying ideologies used to mediate the text meaning. It is important in classrooms to encourage all possible interpretations as the *basis of inquiry* into the underlying basis of meaning.

Second, in a fully semiotic moment, ideological assertions do more than simply mediate the meaning of the text. Semiosis is not just the application of an intertext to the text and context. The meaning works back on, or mediates, the sign in relation to the intertext, and together the sign and meaning mediate the potential intertexts. The three are created simultaneously together and cannot exist alone. They are not independent entities that interact with each other to signify meaning. Even further, each exists as a sign, object, and interpretant within a myriad of other triadic relations, all of which are negotiated within our social interactions in the production of our semiotic consciousness. My key point for teachers

is that semiotics assumes that texts, ideologies, signs, identities, values, and more do not have inherent meanings. A text cannot be applied to another text to derive meaning. Nor can a text be transmediated into another system of signs and have the same meaning. Instead, when two texts are juxtaposed, new meanings are generated for both texts and for all the other texts connected beyond the juxtaposition. Life experience can be reinterpreted through a text, and a text is reinterpreted through life experience. When we read a text a second time, both the text and we are *different*. Our identity is a constantly shifting intertext. In classroom experiences, teachers must work to open up every text's meaning, not by framing it with the correct ideological lens, but by generating more and more connections to other texts to produce new layers of possible meaning. It will be difficult to resist the tendency to close down meaning, because so many of our cultural practices involve reducing possibility to convey an exact idea.

Teaching strategies to open up possible meanings for media texts, rather than to close down the lessons to be learned from a text used in the classroom, are advocated by Arikan in Chapter 9 with ESL learners. For these particular learners, language learning must be embedded in the examination of the cultural contexts in which specific ideas and identities are constructed. Also, in Chapter 6, De Gourville reminds us that popular media texts provide a wealth of opportunity for the study of significant cultural values, relationships, and identities that are constructed through social interactions using the common semiotic systems for meaning-making. While the tendency exists to typify or stereotype the cultural meanings produced by words, acts, and signs in social interactions, if the teacher uses a great number of media texts in a juxtaposed manner, the fluid and shifting conditions of the construction of meaning can also be highlighted.

Dialectical Tensions in a Semiotic Perspective

A few final assumptions of a semiotic perspective relate to tensions between ways of being and thinking that seem oppositional yet can only coexist in a dialectical way. The first of these dialectical tensions is that meaning is simultaneously general and unique, and the second is that meaning is both ideational and material. The analysis of the photographs of Puerto Rican families in Chapter 7 highlights how interpretations of texts simultaneously engage general stereotypical meanings and specific unique meanings. While most literacy practices support more generalized

meanings for texts, the critical media literacy approach recommended in Chapter 7 and elsewhere in this volume encourages the reader/viewer to generate unique understandings about a text to reveal the ideological selectivity that went into the production of the text. Thus, the families are seen as unique identities and not as general representatives of all Puerto Rican families. Even further, their uniqueness framed by the ideological intentions of the author/photographer, in which are revealed by asking what unique aspects the author/photographer sought to generalize to some political purpose. What should not escape critical media analysis is that the viewer/reader's construction of meaning is also steeped within the dialectic of unique and general.

Because it simultaneously embraces the general and the unique, a semiotic perspective on meaning differs from most of the literacy practices in school classrooms. The valuable meanings in the classroom are most always the generalizations that make up what we commonly name the knowledge to be learned in school. While we recognize the individual nature of every student, as teachers we tend to interpret all actions and words in terms of generalized skills and ideas. School learning itself might be best understood as a transmediation in which we reframe every act and word (sign) within a fixed schema of knowledge to make a judgment about how close it matches already generalized ideas. This transmediation of course allows us to arrive at grades and marks, constructing the fundamental ideology of school literacy practices. I am of course quite pleased that none of the authors in this volume provide any grading schemes for critical media literacy activity. For those teachers of older students who often feel compelled to direct every student action and thought and provide prescribed grading rubrics and standards, I draw attention to the experiences with young children shared in Chapter 3. No marking or grading went on during or after those wonderful discussions that took place with first-graders to interpret texts in relation to gendered life activity and possible identity. I propose that the lack of any pressure to mark students in those early grades and the emphasis on supporting what the unique child is attempting to mean and do are largely responsible for the successful construction of a critical media literacy practice in that classroom.

The second dialectical tension engaged by a semiotic perspective on meaning again involves simultaneous aspects of being and consciousness. I believe that Freire (1974) proposes this dialectic succinctly when he says that language allows us to live both in and with the world.

Language, and all of the other semiotic sign systems, allow us to interact "in" the world to accomplish everyday valued activities. This is a kind of firstness in which we use signs to participate in the primary experience of life. Language in particular, but the other sign systems as well, allow us to separate being from the flow of time and space and to reflect on experience—to live "with" the world. This is a kind of secondness in which we generate the possible meanings about life. At each moment we are both "in" social activity and outside of it "with" the larger context and intertext of that activity. At each moment we make meaning with signs and make meaning about the meaning. The dialectical space in between is a kind of thirdness in which we struggle with contested ideologies in order to control the stuff of life by connecting signs with what we want them to mean and do.

We tend to think about existence as involving two planes of experience: a material one in which activity takes place and an ideational one in which ideas and knowledge about the world are accumulated. Sometimes we name these planes as the objective world and the subjective world. In adopting a semiotic perspective on meaning, these separate material and ideal planes of being and consciousness must be dissolved. Ideas can easily be understood as material texts that have as much of a material impact on human consciousness as a physical material object. This is especially the case when ideas become enacted in the material world as media texts. Our identity can also easily be understood as a material text. When we engage the world, we are part of the scene, and our words are taken as material signs to others and our self. Our consciousness is far more than linguistic, thus it is also far more than a schemata of ideas separated from the world.

This dialectical assumption is significant in the construction of critical media literacy practices because the tendency in traditional school literacy practices is toward the construction of right and wrong ideas within an objective body of knowledge that exists beyond the subjective experience of the world. In school discussions of texts in literature classes, as well as social studies and science classes, students must learn to repeat objective bodies of knowledge and then apply the ideas to the material world within their subjective life experiences. This assumption of course makes the construction of any critical practice impossible because it separates one's own consciousness from the material world in which it must ultimately live. Knowledge lives beyond an individual self; this is a dif-

ferent thought from the idea that the social self is a participant in the construction of knowledge.

Transmediation: From Icon, Index, and Symbol to Critique

The activities of transmediation advocated in this volume support the construction of critical media literacy practices by generating within the space of juxtaposed signs a critique of the underlying cultural ideologies that form the intertextual web of all semiotic meaning. Throughout this important volume, the authors' and their students' transmediations subvert the intended or unexamined meanings of media texts. They offer sets of critical questions to make signs problematic. They describe strategies for transmediating texts from one sign system to another to generate new meanings that expand consciousness and agency. As teachers adapt these strategies to their own classroom contexts, it is critical to remember that a semiotic perspective on meaning does not just seek multiple meanings for any text; it also seeks an inquiry into the ideological intertext of experience that would lead one to signify each different meaning. This purpose for a critical media literacy practice can be described in relation to the three semiotic functions of signs as *icons*, *indexes*, and *symbols*. Perhaps, a short description of what I mean by these terms will be helpful in understanding how meaning is made in a transmediation process.

For example, an iconic sign is simply a visual sign. In other words, an iconic sign bears (or signifies) in its form a certain resemblance to the act, person, or event to which it makes reference. Thus, a portrait or a photograph is iconic, in the sense that the signifier represents the appearance of the signified. However, a written or spoken sign is what is called an indexical sign. An indexical sign bears no obvious relationship at all to the things to which it refers. The letters BOOK, for instance, do not look like books on a shelf, nor does the word sound anything like real books, even if you were to drop them. Symbols are easier to explain. A symbol is an image that suggests or refers to something else. For example, the cross is a symbol of Christianity. The lion is a symbol of courage. The relationship between the image and what it signifies is quite arbitrary or simply a result of social convention. These categories of signs—iconic, indexical, and symbolic—are in fact semiotic processes commonly used by humans as a means of talking about or representing what goes on around them.

Mediation and transmediation are similar in that both semiotic processes interpret a sign by generating relationships to other signs. Thus, all meaning is mediated, and transmediation refers to the intentional generation of meaning by relating signs that commonly operate within different sign systems. Purist semioticians would suggest that all is mediation and transmediation alike, but the distinction between the two may help pedagogical activity in classrooms. As a quick example, when a child shares what they did over the weekend through talk or drawing, she is engaged in mediating meaning. Of course children often talk as they draw and mix words and image. If the child intentionally re-represents either the spoken or the drawn story in pantomime, then she is engaged in transmediation.

All transmediations do not generate the same amount of inquiry into the intertextual web of relational signs that form various cultural ideologies. To maximize the critique of a meaning in ideological terms, students must be encouraged to move beyond iconic, indexical, and even symbolic transmediations as represented in Figures 1, 2, and 3 below (Myers 1997; Myers, Hammett, and McKillop 1998). In Figure 1, an iconic transmediation occurs when a new sign is simply substituted for the original sign in the triadic meaning. If the child reads a poem about a victorious basketball game and simply draws the picture of a basketball, this highly literal representation does little to generate any critique of the belief systems underlying meanings for the original text. In Figure 1, this iconic relationship is illustrated by a new sign that simply replaces the old sign in the same triadic sign-object-interpretant relationship.

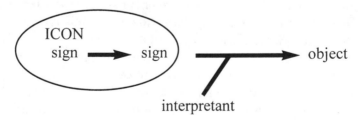

Figure 1: An Iconic Juxtaposition (Source: Myers 1997)

An indexical transmediation would involve connecting a new sign that points to the same object meaning, again without any questioning of the underlying beliefs by the interpretant. The picture of a soccer player scoring a goal might be juxtaposed with the basketball poem. The new

meanings generated reinforce the underlying ideologies of both texts but increase their visibility to some degree. In Figure 2, the indexical relationship is illustrated by having two signs point to the same object.

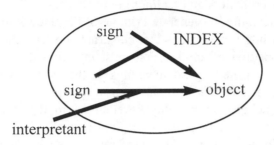

Figure 2: An Indexical Juxtaposition (Source: Myers 1997)

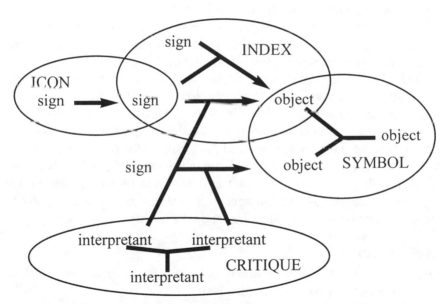

Figure 3: Triadic Relationships for Iconic, Indexical, Symbolic, and Critiquing Juxtapositions (Myers 1997)

A symbolic transmediation juxtaposes an entirely new triad of sign-object-interpretant in order to focus attention to the shared meaning between the two different texts (see Figure 3). For example, a child might

pantomime a difficult climb to the top of a mountain and on top plant a flag and stand up tall and proud. Juxtaposing this text with the basketball poem creates a symbolic relationship and generates a new meaning focused squarely on beliefs and feelings about success.

For a transmediation to generate critique of the underlying interpretants—at web of intertextual signs that constructs our contesting ideologies—the juxtaposition of another text must intentionally focus on the interpretants of the possible text meanings. If the student juxtaposes a video clip of a coach yelling at a player on the bench with the crowd's reactions in the background with the basketball poem, then the meanings related to success and victory in the original text of the poem are dislodged and made problematic. The interpretants become the focus for thought in the transmediation, and a critique that connects the signs of the text to possible meanings to cultural ideologies has been generated and the only consequence can be the expansion of consciousness and future agency in the wielding of signs in social interaction.

I have found that students love to juxtapose texts in ways that at first instance might seem totally absurd but that actually generate some of the most interesting inquiries into human relationships, purposes, being, and identity. I have also found that, like the first-graders in Napoli's classroom in Chapter 3, the students quickly begin to probe all the texts of the world and discover many texts that in their very construction attempt to cut off the underlying interpretant ideologies in order to communicate a meaning that serves the interests of some and marginalizes the possibilities of others. I encourage teachers to put to practice the many transmediations shared in this volume to construct critical media literacy practices that expand our consciousness and agency in our acts and words in order to achieve more socially just identities and relationships.

References

Blumer, H. 1969. *Symbolic interactionism: Perspective and method.* Englewood Cliffs, NJ: Prentice Hall.

Bruner, J. 1986. *Actual minds, possible worlds.* Cambridge, MA: Harvard University Press.

Eco, U. 1979. *The role of the reader.* Bloomington, IN: Indiana University Press.

Dewey, J. 1963. *Experience and education.* New York: Macmillan Publishing Company.

Freire, P. 1974. *Pedagogy of the oppressed.* New York: Continuum.

Lave, J., and E. Wenger. 1991. *Situated learning: Legitimate peripheral participation.* New York: Cambridge University Press.

Myers, J. 1997. "Social constructivism and intermediality." Paper presented at the National Reading Conference 47th Annual Meeting, Scottsdale, Arizona.

Myers, J., and R. Beach. 2001. Hypermedia authoring as critical literacy. *Journal of Adolescent and Adult Literacy* 44, no. 6: 538–546.

Myers, J., R. Hammett, and A. M. McKillop. 1998. Opportunities for critical literacy/pedagogy in student-authored hypermedia. In *Literacy for the 21st century: Technological transformations in a post-typographic world,* edited by D. Reinking, L. Labbo, M. McKenna, and R. Kieffer. Mahwah, New Jersey: Lawrence Erlbaum Associates, Inc.

Scribner, S., and M. Cole. 1981. *The psychology of literacy.* Cambridge, MA: Harvard University Press.

Street, B. 1995. *Social literacies: Critical approaches to literacy development, ethnography, and education.* New York: Longman.

Vygotsky, L. V. 1981. The genesis of higher mental functions. In *The concept of activity in Soviet psychology,* edited by J. V. Wertsch. Armonk, NY: Sharpe.

Glossary

Aesthetic stance. The approach of a reader toward a text that focuses attention on her or his senses and feelings in the experiencing of the text; that is what is being lived through during the reading event. Aesthetic responses are personal and unique since private language nuances come into play along with personal associations, attitudes, and values.

Anglo-American. Technically, an American of English descent or something characteristic of English and American culture; used more generally to refer to any English-speaking U.S. citizen of northern European ancestry or to do something characteristic of the dominant culture in the United States.

Artifact. Cultural Artifact. These terms are borrowed by media literacy educators to talk about media artifacts such as photographs in magazines but also to intangible verbal, visual and auditory expressions, such as those in a rock music video. In anthropological usage, the term artifact refers to any human-created object. Cultural studies scholars use the terms as a way of broadening the definition of what aspects of culture in modern societies are worthy of serious study. See also *Artifacts*. These are personal objects that influence how we see ourselves and how we express our identities.

Codes, Semiotic codes, Media codes. These terms are used in semotics-influenced media studies to refer to rules and conventions that structure representations on a number of levels—some specific to certain media such as narrative film or advertising photographs, whereas others are

shared with other modes of communication. Audiences learn to "read" the conventional, verbal, visual and auditory features that make the "languages" or "sign systems" of media and other cultural forms in much the same way children learn the complex, often arbitrary systems of meaning in natural languages.

Cognitive development theory. Claims that children participate actively in defining their genders by acting on internal motivations to be competent, which lead children to seek out models of gender that allow them to sculpt their own femininity and/or masculinity.

Commodify. To commodify something is to turn into a commodity. A commodity is any object or service that can be bought and sold in the marketplace. Marxists argue that capitalism reduces all aspects of life to commodities.

Communication. A dynamic, systematic process in which meanings are created and reflected in and through human's interactions with symbols.

Connotation. The implicit or understood meaning of a word or phrase (as opposed to the explicit definition, or denotation.) Example: In practical terms, "home" simply refers to where you live, but it also has connotations of warmth, comfort, love, and privacy.

Consumerism. This concept refers to the endless buying or consumption of products, motivated not by need but a desire for novelty or status. Example: One sign of our society's consumerism is that, whether we are shopping for soap, or stereos, we encounter a dizzying variety of brands and styles; shopping malls are a manifestation of such consumerism.

Critical literacy. An alternative pedagogy that examines the politics and sociolinguistic stances. Also, the adjective "critical" and its correlates, "criticism," "criticize," and "critique," convey the idea of judging, comparing, or evaluating on the basis of careful analysis. Colin Lankshear insists that critical literacy consist of analytic habits of thinking, reading, speaking, or discussing which go beneath surface impressions, traditional myths, mere opinions, and routine clichés, understanding the social context and consequences of any subject matter; discovering the deep

meaning of any event, text, technique, process, object statements, image, or situation; applying the meaning to your own context.

Criticism, Critique. Criticism often means a critical evaluation of a work, subject, or idea; the practices of making such an evaluation. A literary criticism that is based on the primacy of the text. The literary work is perceived as an object, autonomous from the world. The text is examined objectively with close analysis of the internal interrelationships, such linguistic relationships as word interactions, figures of speech and symbols, and the central theme.

Cultural feminists. A group of feminists who believe women and men differ in fundamental ways, including these: Women are more moral, nurturing, concerned about others, and committed to harmony. These allegedly womanly qualities are celebrated and were often referred to as "the cult of domesticity" in first wave of feminism.

Cultural studies. This is an approach to the study of communications in society that is drawn from a number of sources, including Marxism, semiotics, literary and film analysis, psychoanalysis, feminism, and African-American or Third World (postcolonial) studies. When used by critical medial literacy educators, it locates the production, textual construction and consumption of media texts in a society characterized by multiple systems of inequality. Of key importance is the study of the role that media forms play in the production and reproduction of these systems of inequality.

Culture. The structures and practices, especially communication ones, through which a culture produces and reproduces a particular social order by legitimizing certain values, expectations, meanings, and patterns of behavior. In traditional humanities fields, such as art history and literature, culture has tended to be conceptualized as the highest-status arts of the wealthy and socially dominant such as oil paintings, opera or poetry. Cultural studies theorists reject this view of culture as elitist, replacing it with the more anthropological usage.

Curriculum integration. Integration refers to a process that attempts to unify a fragmented curriculum by stressing common themes and competencies among subjects. In curriculum integration, unit planning begins

with a central theme and proceeds outward through identification of big ideas or concepts related to the theme and activities that might be used to explore them. This planning is done without regard of subject area lines, since the overriding purpose is to explore the theme itself. In an integrated curriculum students move from one activity or project to another, with each one involving knowledge from multiple sources.

Discourse. Communication through speech or writing. Stuart Hall (1997) describes discourses as ways of referring to or constructing knowledge about a particular topic or practice: a cluster of ideas, images, and practices that provide ways of talking about and forms of knowledge and conduct associated with a particular topic, social activity or institutional site in society. Example. Many groups adopt a distinctive style of discourse that distinguishes members from nonmembers. Note also: "Level of discourse" refers to the relative difficulty or formality of a writer's style; "discourse community" refers to a group of people who share a particular vocabulary or style of expression.

Ethnicity. Affiliation with a particular ethnic group. Example. Since the 1960s, many African-Americans, Italians, and Puerto Ricans have asserted pride in their ethnicity, learning, or relearning the history and customs of their ancestors.

Feminism. The assertion of any or all of the following principles: (1) the social and political equality of women; (2) the absolute worth of women, and the qualities and values associated with them; (3) the need to reshape culture around such "feminine" values as cooperation, nurturance, and nonviolence. Also, the social political movement that advocates these principles. An approach to literature that takes into account the image of women characters in texts, the place of women writers in the literary canon, and the unique responses of female readers to texts as contrasted to those of male readers. In the assumption that the reader (i.e., gender) is significant in establishing meaning, feminism criticism falls within the reader response context. Take note of Liberal feminism. This kind is distinguished from structural feminism, maintains that women and men are alike in important respects and that women should have the same economic, political, professional, and civic opportunities and rights as men. (Also called middle-class feminism and white feminism.) This is a countermovement that seeks to repudiate and contain feminism by arguing two

contradictory claims: (1) Women have never had it so good, so there is no longer any need for feminism, and (2) feminism has caused serious problems in women's lives and family relationships.

Framework. Analytical Framework. A framework refers to the process or various structural elements within an easily identifiable, unvarying organizational pattern. A critical media literacy framework provides systematic analytic mental processes to critique existing sociocultural systems in the context of how such sociocultural systems relate to structures of domination and forces of resistance by identifying the ideological positions these systems advance within the context of current debates and social struggles for a more democratic and egalitarian society. Such process of critical mindedness generates in teachers and students the habits of questioning, inquiry, reflection, and action to resist or reject hegemonic practices or ideology.

Gender. Gendered reading. A social, symbolic construction that expresses the meanings a society confers on biological sex. This terminology is used to suggest the impact of the gender of a reader on her or his response to and interpretation of a text.

Glass ceiling. An invisible barrier that limits the advancement of minorities and women. Making up the glass ceiling are subtle and often unconscious prejudices and stereotypes that limit women's and minorities' opportunities.

Hegemony. Hegemony is a term developed by Italian Marxist theorist Antonio Gramsci to refer to the process of which those in power secure the consent of the socially subordinated to the system that oppresses or subordinates them. Rather than requiring overt force (as represented by the military or police), the elite, through their control of religious, educational and media institutions, attempt to persuade the populace that the hierarchical social and economic system is fixed and "natural," and therefore unchangeable. According to Gramsci, however, such consent is never secured once and for all but must continually be sought, and there is always some room for resistance through subversive (counter hegemonic) cultural work.

Hidden curriculum. The organization, content, and teaching styles of educational institutions that reflect gender stereotypes and sustain gender inequalities by marginalizing and devaluing female and minority students.

Ideology. This is a complex concept and it carries several meanings. In the formal sense, ideology is a systematic body of ideas about life, politics and culture. Used in this traditional way, ideology is almost identifiable with philosophy—a self-conscious and rational account of one's ideas and belief about the world. The term is also typically used to denote the total of one's beliefs, ideas, and values—unconscious as well as conscious. In this sense, when we refer to the ideology of a historical era, or an entire nation, we mean the ideas, values, and beliefs that appear to dominate the events associated with it. The term is often also used to disparage the ideas and views of a political or philosophical opponent. In this sense, the term carries the implication of false or extreme ideas. Today, critical theorists tend to use a broader concept of ideology. For example, "the complex of ideas in society and their expression in social institutions, whether the military or the arts or the courts, which in turn dominate the way we live and how we understand the world around us." In short, it is a systematic way of manipulating the belief system of the population to convincing them to accept things as natural and unchanged.

Image. Impression, representation, or picture. Image has two distinct meanings for media critics: (a) any representation of social reality, as in "image of women in media;" (b) a visual representation as in a picture or cartoon. In literary studies, this word is used to refer to both the sensory experiences produced in the mind by the verbal description of perceptual events (appearances, sounds, smells, physical sensations, etc.) and to the verbal descriptions that themselves produce these mental impressions.

Intertextuality. John Fiske has explained a theory of Intertextuality to help explain the way audiences experience a wide variety of media texts as interrelated, allowing their knowledge of one to influence their reading of another. "The theory of Intertextuality proposes that any one text is necessarily read in relationship to others and that a range of textual knowledges is brought to bear upon it."

Journal response. When used with literature, the purpose of this writing activity is to engage or elicit the reader's personal response to a text. It is intended as a process response, a reflection of spontaneous feelings and attitudes. These are several names and formats for such journals, including reading journal, learning log, and dialogue journal. The last involves a written dialogue between two readers responding to a text, perhaps two students or a student and a teacher.

Male generic language. Words and phrases that claim to include both women and men yet refer specifically only to men. Examples of male generic terms are: mailman, mankind, and chairman.

Marxist criticism. An approach to literary criticism that is based on the economic and cultural theory of Karl Marx. Such critics examine the ideological background of the authors and the expression of social realism in the text. To the extent that the reader is significant in establishing meaning, Marxist criticism falls within the reader-response context. Focuses on how capitalist system created economic inequalities between the sexes by sustaining a sexual division of labor that subordinates women and privileges men.

Multicultural. Multiculturalism refers to a movement affecting curricula, teaching methods and scholarship in a variety of fields within universities and colleges in the United States. The broad objectives of activists in this educational movement include democratizing knowledge and education, by bringing to the foreground and validating the experiences and perspectives of all those groups historically marginalized or culturally and socially dominated in our society. A multicultural practice sees the importance of analyzing the dimensions of class, race, ethnicity, gender, and sexual preference within the texts of media culture. Such a practice also studies how audiences read and interpret the social dynamics. Collectively, these practices go beyond the superficial image or symbol to attack the representations of sexism, racism, or bias against specific social groups and criticize texts that promote any kind of domination or oppression.

Myth. A story that depicts, in a richly symbolic or imaginative way, the basic values and structures of a particular culture or civilization. Myths often address themes like the creation of life, the founding of civilization,

the birth and rebirth of a god or of nature. They also frequently employ bizarre or fantastic events and characters. Unlike legends and sagas, myths cannot easily be traced to remembered historical events. In media literacy literature, myths refer to narratives that espouse ideals, and values we have come to identify with national character and raised to the claim that "that's how things are," implying unchanging features and therefore denying any possibility of critique.

Narrative. An account in prose or verse of actual or fictional events—a story. While the term narrative is generally applied only to fictional works of literature, it may also be used to describe historical or journalistic works depicting factual events.

Perspective. Multiperspectival. A perspective is one's mental view of facts or ideas and their relationships. In media literacy, both terms, point of view and perspective, refer to a "worldview." A multiperspectival practice acknowledges the multiple perspectives and subject positions individuals bring with them when they interact with cultural texts. A multiperspectival practice is also multidimensional. A multidimensional practice examines the multiplicity of levels embedded in a cultural text from the literal level to its context.

Postmodernism. In the wake of many influential applications of the term postmodern to aspects of contemporary, media-formed sensibility that many observers find discouraging or even frightening, those who use the term acknowledge that it is used in so many different ways as to be virtually impossible to define. Originally, postmodern referred, in literary and art criticism, to "art, architecture or literature that reacts against earlier modernist principles." Modernism was itself "the deliberate departure from tradition and the use of innovative forms of expression," in many styles of European art and literature in the early Twentieth century. In cultural studies as referenced by media theorists, it refers primarily to a particular style of televisual aesthetics best displayed in music videos and the MTV Channel. John Fiske emphasized the notions of fragmentary nature of images, their resistance to sense, the way that the images are more imperative than the real and have displaced the real in our experience.

Preferred reading. This is a concept developed by Stuart Hall to circumscribe the degree of "openness" of media texts. According to Hall, the

structure of mainstream media texts always "prefers" or strongly suggests a single "correct" meaning that tends to promote the dominant ideology. Within cultural studies, there continues to be a lively debate over whether a preferred meaning can be said to be a property of the text; some would argue that the making of meaning ultimately resides with individuals, the audiences.

Proxemics. Space and the human use of space, including personal territories.

Racism. Racist. Many people tend to think of "race" as a fixed entity linked to biological realities. However, in critical theory generally, "the effort must be made to understand race as an unstable complex of social meanings constantly being transformed by political struggle. In everyday usage, racism can be used to mean holding or displaying prejudiced or bigoted attitudes or indulging in discriminatory behavior toward someone else (usually toward people of color but sometimes toward Whites as well) on the basis of that person's apparent race, ethnicity or color. However, in critical theory, the term refers to the White-supremacist ideology encoded into and characteristic of the major social, cultural and economic institutions of U.S. society.

Reader response approach. The application of reader response criticism. Teachers establish a classroom climate using appropriate language, stance, processes, and procedures to encourage the active role of the reader with the text; readers use the concepts embodied by the theory as reader and text in which they go beyond merely affecting one another; each conditions and is conditioned by the other. That body of criticism that focuses on the reader relation to the text as differentiated from other critical theories which ignore or reject the reader. There is an array of critical positions referred to by this terminology which are generally differentiated by their orientation toward the reader, toward the text or toward the reader-and-text. By invoking the role of the reader as active recreater of text, reader response criticism recognizes the validity of more than one interpretation, thus rejecting the notion of a single determinate meaning of a text.

Representation. Media representation. These terms refer to the "creation of a convincing illusion of reality" through such media as painting, draw-

ing, graphic prints, still photographs, films, recorded sound, live acting on stage, television technology, computer graphics and the like. Representations include all kinds of media imagery that, no matter how convincing their likeness to everyday social reality, are always to be recognized as "constructions taken from a specific social and physical viewpoint, selecting one activity or instant out of vast choices to represent, and materially make out of and formed by the technical processes of the medium and its conventions."

Selective attention. This term is borrowed from reader response criticism and used in critical media literacy education to broaden the critical "reading" and multiple interpretations possible of a text. In a reading context, this term refers to the reader's process of selecting certain features of the text to relate to, certain subtleties of language and relationships to focus on or minimize. Consciously or unconsciously, the reader processes the text according to her or his dominant reader stance and interest, and is influenced by individual language and life experiences. The process is dynamic in the sense of response to individual elements and in the evolving of responses—shifting and changing, the building and restructuring that occurs as the reader proceeds through the text.

Semiotics. Semiology. Semiotics is the study of "signification," or the ways in which both languages and nonlinguistic symbolic systems operate to associate meaning with arbitrary "signs," such as words, visual images, colors or objects. Semiotics is a linguistics-based field of study that has had an important influence on the way cultural studies scholars discuss the "codes" in media texts.

Social learning theory. This theory claims that individuals learn to be masculine and feminine (among other things) by observing and imitating others and by reacting to the rewards and punishment others give in response to their imitative behaviors. Social learning is also a form of socialization process.

Stance. The approach that a reader adopts toward the reading of a text, that is, to what the reader consciously or unconsciously directs her or his attention. A continuum of response possibilities (stances) exist from the predominantly aesthetic to the predominantly efferent and in between. The same text may be read in either direction, toward the efferent or

toward the aesthetic, by different readers or by the same reader at different times.

Stereotype. A broad generalization about an entire class of phenomena based on some knowledge of limited aspects of certain members of the class. More often now, the term refers to a standardized, preconceived view of something or someone that fails to acknowledge individual differences. In media literacy, the term often refers to negative stereotypes of ethnic groups— prejudged or prejudiced expectations that Asian students will be good in math, that Latinos are hot-tempered, and so on. Many groups battle stereotypes, including women, gays, and the elderly. Negative stereotypes perpetuate the denigration of subordinate or non-white groups as a form of differentiation and as fertile ground for ethnic derogatory jokes or in the name of harmless entertainment.

Symbol. A word, phrase, or object that represents or stands for something else. We all recognize numerous symbols in ordinary life. For example, a badge is a symbol of authority, a handshake symbolizes friendliness. The flag is symbol for patriotism or a nation, nationalism or love of one's country; the swastika is a symbol of Nazi Germany and the propaganda of supremacy of the Arian nation. Textual analysis or a close examination of how particular media texts generate meaning, is one of the key activities of critical media literacy and contemporary cultural studies.

Symbolic interactionism. Theory that claims individuals develop self-identity and an understanding of social life, values, and codes of conduct through communicative interactions with others in a society.

Text. Media text. Originally referring to a verbal/written cultural artifact (such as a story, play, or song lyrics), text is now used much more broadly by critics. It can refer to any communicative or expressive artifact produced by the media industries or a variety of meaning-making devices such as words in basic verbal communication, images, pictures, media messages, motion pictures, songs, and more recently the multimedia inventions including iconic texts found in computer operations and in Internet communications. A media text can also be an illustration or symbolic presentation.

Theory. A theory is a way to describe, explain, and predict relationships among phenomena.

Transaction. This term is sometimes applied in a reading context to establish the dynamic relationship of reader and text in which they go beyond merely affecting one another; each conditions and is conditioned by the other. The term transaction is differentiated from interaction which suggests two discrete elements acting on each other. This is a theoretical approach within the reader-response spectrum which insists that the reader and the text are mutually essential elements of a reading event. The text acts as a catalyst or stimulus for the reader, activating aspects of her or his personality and experience, as well as a guide or constraint during the reading process. The reader responds to the text as influenced by these aspects and the immediate situation, selecting features and nuances of language and relationships according to these internal/external factors.

Transmediation. The process of taking understandings from one sign system and moving them into another in order to make meaning or "representing" meaning across sign systems.

Validate. To give approval, respect, or credit to. A teacher can validate a student's opinion by truly listening to them and responding thoughtfully and honestly.

Validity. A term used by language scholars denoting the appropriateness of a reading—interpretation—as measured against the constraints of the text. An out-of-context response or a strongly skewed response may be said to be an invalid or a less valid transaction within the text. This is not intended to suggest that there is a single correct interpretation or meaning of a literary work.

Voice. In informal uses, voice is the distinctive style of an author or a particular piece of writing. In critical pedagogy, however, voice refers to principles of dialogue as they are enunciated and enacted within particular social settings. Voice is fundamental to the struggle for democracy and equality in the classroom, particularly as it relates to the development of voice in students of color. It is connected to the control of power and the legitimation of specific student discourses as acceptable truths or rejected fallacies, and consequently determines who speaks and who is silenced.

In his book, *Teachers as Intellectuals*, Henry Giroux explains that voice represents the unique instances of self-expression through which students affirm their own class, culture, racial, and gender identities. A student's voice is necessarily shaped by personal history and distinctive lived engagement with the surrounding culture. The category of voice, then, refers to the means at our disposal—the discourses available to us—to make ourselves understood and listened to, and to define ourselves as active participants in the world.

Writing to learn. The use of writing as a tool for learning rather than for learning to write. It places emphasis on the writing process rather than on completion of a product. Frequently, it uses the short writing activities often associated with prewriting and prereading.

List of Contributors

RENÉ ANTROP-GONZALEZ is assistant professor of Curriculum and Instruction at the University of Wisconsin-Milwaukee. His research interests include the education of Puerto Ricans in the United States, critical curriculum theory, and qualitative inquiry.

ARDA ARIKAN is doctoral candidate in curriculum and instruction at the Pennsylvania State University.

PEI-YU CHANG is assistant professor at National Taipei College of Nursing. Her research interests include children's art, play, and cultural influences on early childhood education.

RICHARD E. DE GOURVILLE is doctoral candidate in curriculum and instruction at the Pennsylvania State University.

JUDITH FUEYO is associate professor at the Pennsylvania State University. Her research explores ways alternative sign systems contribute to writing/thinking.

WILLIAM GARCIA-CARDONA is doctoral candidate in curriculum and instruction at the Pennsylvania State University and currently teaching bilingual education in Puerto Rico.

SARAH GREEN is a doctoral candidate in curriculum and instruction, specializing in language and literacy education at the Pennsylvania State

University. Her research examines signifiers of masculinity in reading and writing school practices.

DEB MARCIANO is assistant professor of curriculum and instruction at the Pennsylvania State University, Altoona. Her research examines representations of schooling in children's picture books.

JAMIE MYERS is associate professor at the Pennsylvania State University. His scholarship explores the social contexts of classroom literacy events with particular attention to the cognitive, social, and political consequences of culturally valued curricular designs.

MARY NAPOLI is a doctoral candidate in curriculum and instruction at the Pennsylvania State University and currently teaching in the Education Department at Elizabethtown College, PA.

LADISLAUS M. SEMALI is associate professor of education at the Pennsylvania State University, where he teaches media literacy to preservice teachers. His work has been published in the *International Review of Education, Comparative Education Review,* and *Pennsylvania Educational Leadership*. Research interests explore the comparative study and analysis of media languages, contexts of cross-cultural literacy curricula, and critical media literacy across the curriculum. He is author of several books in literacy education and recently he authored *Literacy in Multimedia America: Integrating Media across the Curriculum*.

Index

Studies in the Postmodern Theory of Education

General Editors
Joe L. Kincheloe & Shirley R. Steinberg

Counterpoints publishes the most compelling and imaginative books being written in education today. Grounded on the theoretical advances in criticalism, feminism, and postmodernism in the last two decades of the twentieth century, Counterpoints engages the meaning of these innovations in various forms of educational expression. Committed to the proposition that theoretical literature should be accessible to a variety of audiences, the series insists that its authors avoid esoteric and jargonistic languages that transform educational scholarship into an elite discourse for the initiated. Scholarly work matters only to the degree it affects consciousness and practice at multiple sites. Counterpoints' editorial policy is based on these principles and the ability of scholars to break new ground, to open new conversations, to go where educators have never gone before.

For additional information about this series or for the submission of manuscripts, please contact:

> Joe L. Kincheloe & Shirley R. Steinberg
> c/o Peter Lang Publishing, Inc.
> 275 Seventh Avenue, 28th floor
> New York, New York 10001

To order other books in this series, please contact our Customer Service Department:

> (800) 770-LANG (within the U.S.)
> (212) 647-7706 (outside the U.S.)
> (212) 647-7707 FAX

Or browse online by series:

> www.peterlangusa.com